COUNTY LINE ROADS

Poems & Photos by
BOB NANDELL

PBL Limited
Ottumwa, Iowa

County Line Roads
copyright 2014 by Bob Nandell
Cover design copyright 2014 by Michael W. Lemberger

First edition published 2014

10 9 8 7 6 5 4 3 2 1

ISBN 13: 978-1500966515
ISBN 10: 1500966517

Printed in the United States of America

Photo credits: Photographs by Bob Nandell

All rights reserved. Except for brief passages quoted in any review, the reproduction or utilization of this work in whole or in part, in any form or by any electronic, mechanical, or other means, now known or hereinafter invented, including xerography, photocopying and recording, or in any information storage and retrieval system, is forbidden without the express permission of the publisher. For permission contact:
 Rights Editor
 PBL Limited
 P.O. Box 935
 Ottumwa IA 52501-0935
 pbl@pbllimited.com

Visit our website at www.pbllimited.com for more information, including quantity prices.

COUNTY LINE ROADS

COUNTY LINE ROADS

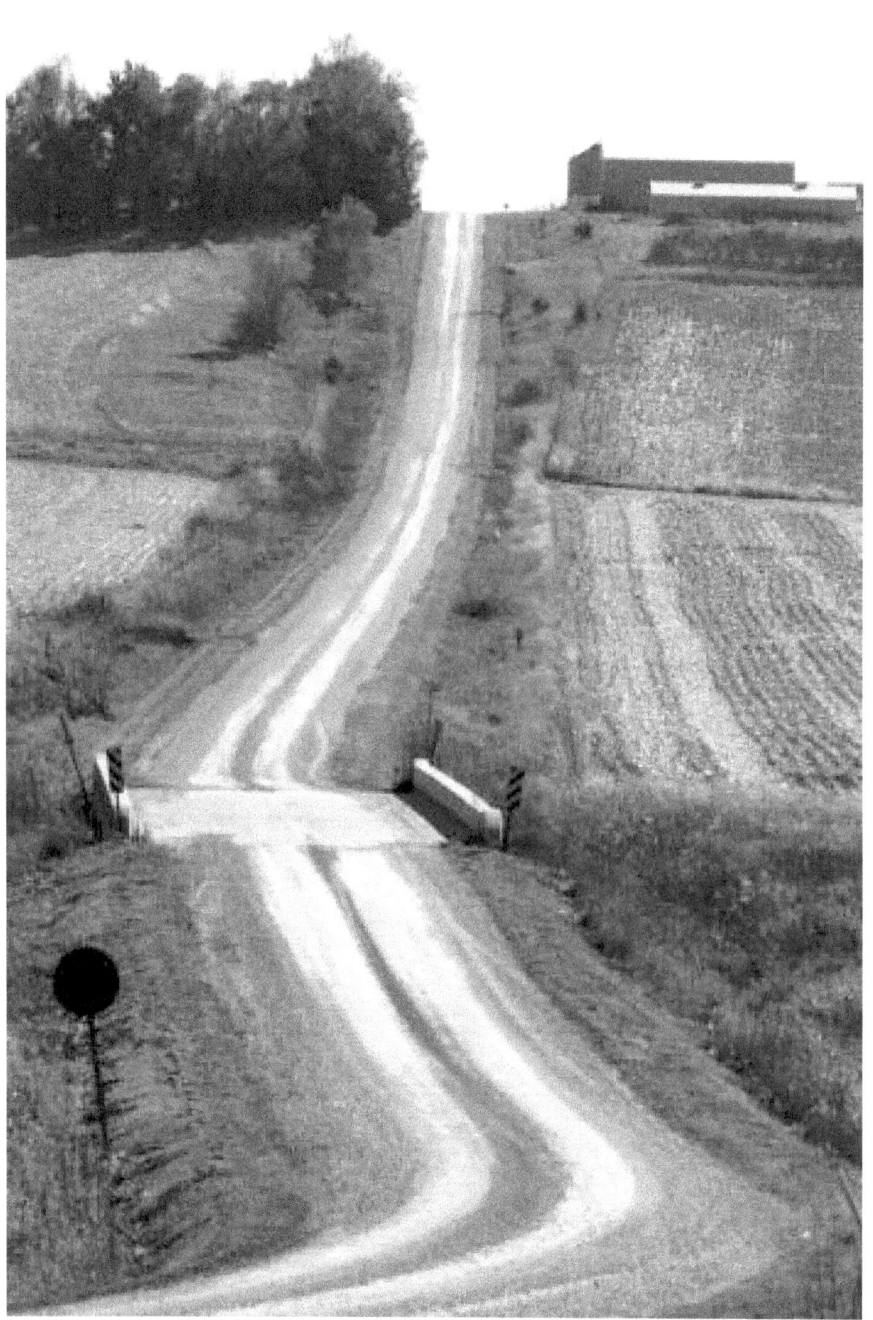

BOB NANDELL

FOREWORD

Seeing Iowa's landscape from the air is like viewing a huge patchwork quilt.

Viewed from an airplane flying five thousand feet above, the land appears to go on forever. Everything is in tidy squares of forty, eighty, one hundred sixty, or six hundred and forty acres.

Only stream beds, railroads, and a few stretches of interstate highways run at odd angles to this pattern. Here and there, white gravel farm roads are interrupted by the gray of concrete-paved state highways and black lines of asphalt-paved county line roads.

Pioneer surveyors laid things out with wooden stakes and chains, ensuring precision. Twenty links of chain equaled one rod, or sixteen and a half feet. One hundred and sixty square rods equaled one acre. One hundred sixty acres equaled one quarter of a square mile section. On west from the Mississippi River they went, marking endless miles of prairie grass that became Iowa's greatest asset, its farmland.

Records of who came to own these square miles and their subdivisions rest on dusty courthouse shelves. Within the yellowing pages of plat books are generations of names. We know little about these people today, because they never achieved big city fame or national glory. What happened during their lives? Who were these people? How did those names change over a number of generations?

As a tribute in these prose poems, I have borrowed names from old courthouse plat books to create a patchwork of fictional Iowa lives and spirits.

COUNTY LINE ROADS

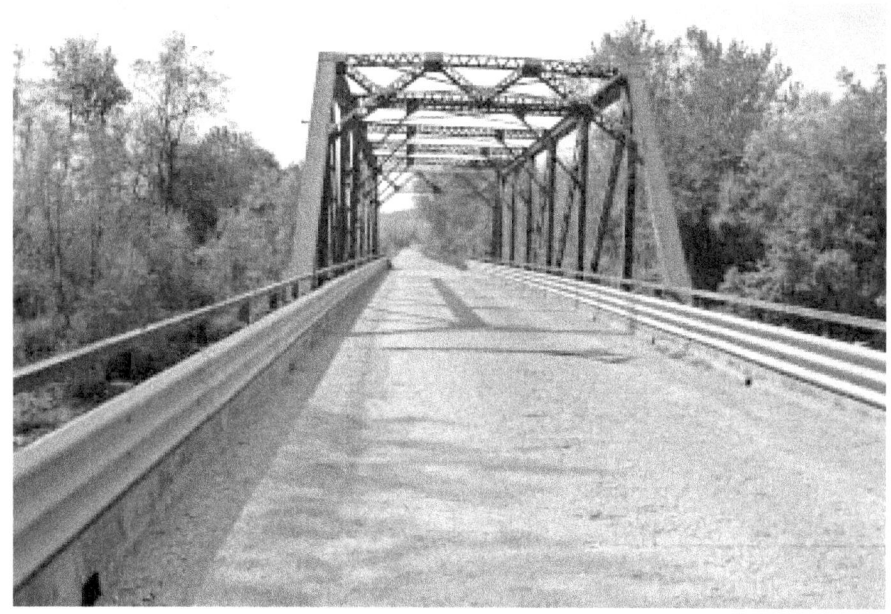

Accompanying photographs are of real places I have encountered while traveling across expanses of Iowa's northern counties.

Iowa's quilt-like landscape holds many memories. It has seen rapid transformation away from the bucolic image of red barns surrounded by cornfields so often presented in national media. Iowa's rural small towns have been faced with rapid changes. Some changes have been brought about by agribusiness and government decisions made in distant cities, far from the aspects of rural life. Some towns have lost population and prosperity, while others flourish.

This book salutes the people who still work in the towns and farms dotting Iowa's landscape. Their tenacity and persistence are remarkable.

--Bob Nandell

BOB NANDELL

51

TABLE OF LAND MEASUREMENTS

LINEAR MEASURE		SQUARE MEASURE		
1 inch0833 foot	16½ feet 1 rod	144 sq. in. 1 sq. ft	43560 sq. ft 1 acre	
7.92 inches 1 link	5½ yards 1 rod	9 sq. ft. 1 sq. yd	640 acres 1 sq. mile	
12 inches 1 foot	4 rods 100 links	30¼ sq. yds 1 sq. rod	1 sq. mile 1 section	
1 vara 33 inches	66 feet 1 chain	16 sq. rods 1 sq. chain	36 sq. miles 1 township	
3¼ feet 1 vara	80 chains 1 mile	1 sq. rod 272¼ sq. ft	6 miles sq 1 township	
3 feet 1 yard	320 rods 1 mile	1 sq. chain 4356 sq. ft	208 ft. 9 in. sq. 1 acre	
25 links 16½ feet	8000 links 1 mile	10 sq. chains 1 acre	80 rods sq. 40 acres	
25 links 1 rod	5280 feet 1 mile	160 sq. rods 1 acre	160 rods sq. 160 acres	
100 links 1 chain	1760 yards 1 mile	4840 sq. yds 1 acre		

SAMPLE SECTIONS SHOWING RECTANGULAR LAND DESCRIPTIONS, ACREAGES AND DISTANCES

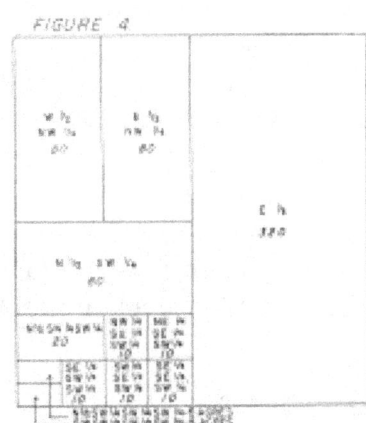

ALTA'S STOVE

Alta Marie wouldn't hear of it.
Her husband wanted to get her a new propane stove.
But she still remembered the boom she heard
 when a propane blast
Blew up a house four miles down County D50.
For decades she clung to her huge black Hercules wood stove.
It kept their whole farmhouse warm every winter.
A blue porcelain coffee pot was always gurgling full atop it.
A big steel pot served as a continuous supply of molten grease.
A huge iron skillet was kept full of fried potatoes and onions
To serve as all-day snacks for men working chores.
Nearby timber meant a continuous supply
 of split wood for fuel.
Alta Marie even heated big kettles of water for baths
 on her stove.
She baked endless pans of fresh bread in a side pocket.
She canned endless jars of vegetables atop it.
She baked huge hams, turkeys, and roasts in its spacious oven.
She dumped buckets of ashes into a cistern
 outside her back door.
They found her lying on the basement steps one morning.
She died with a stack of firewood in her arms.

BOB NANDELL

COUNTY LINE ROADS

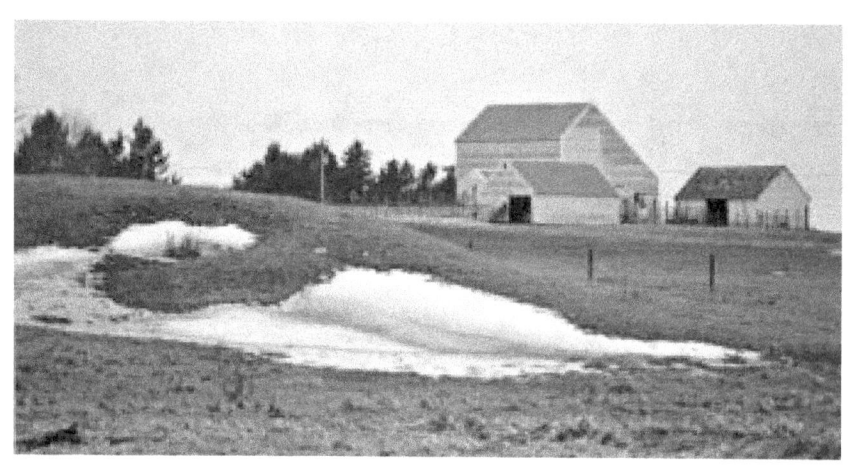

BOB NANDELL

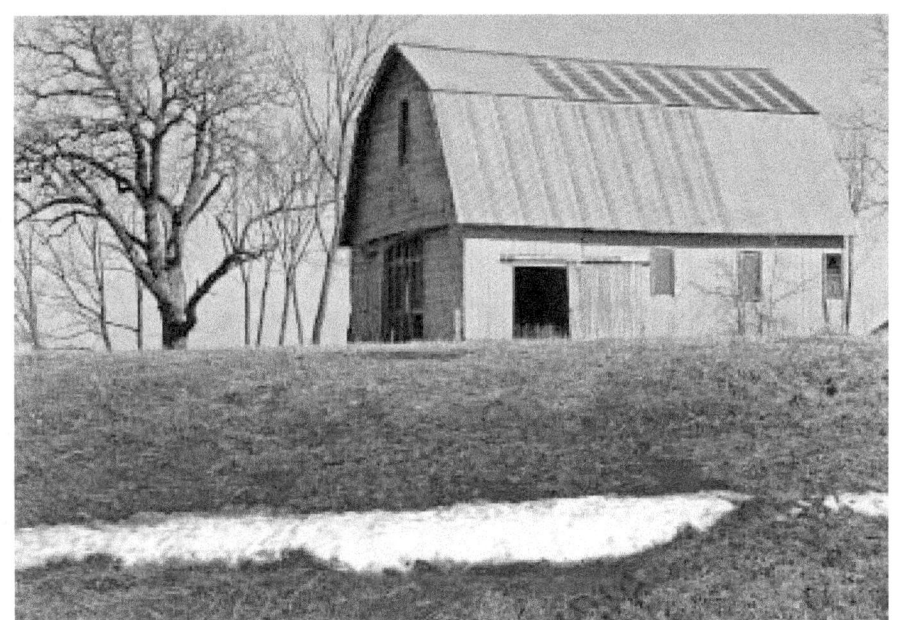

BEGINNINGS

Every day that snowdrift alongside County G4R
 is getting smaller.
Sunshine is warming weathered barn boards north of it.
Fields frozen hard as concrete are grudgingly softening.
Tiny buds adorning a few low wind-whipped branches
 give hope.
Another winter has been survived.
Farm machinery shed doors are opening.
Tanker trucks deliver first loads of diesel fuel.
New cycles of farm life begin.
Tractor wheels will soon roll down miles of county roads.

BILL AND JOE

Brothers Bill and Joe managed to scratch out a living.
They did it on eighty scruffy acres along County F28.
Bill raised pigs.
Joe raised cattle.
Bill grew corn.
Joe grew hay.
Hot summer afternoons would find them
 sitting on their porch.
They listened to White Sox games on WGN radio
 from Chicago.
They smoked William Penn cigars and drank Grain Belt beer.
They watched year after year as suburban rooftops
 marched closer.

BOB NANDELL

They laughed when expanding city limits
 annexed their cow pasture.
They laughed when new homeowners didn't like
 summer pig smells.
They finally just gave up raising anything altogether.
It was easier to sit on their porch and listen to ball games.
It was easier to live on money received from selling
 their pasture.
They didn't live long enough to see the funniest scene of all.
A huge suburban house now sits where Bill's pig pen was.
A row of tract houses, dreary in their architectural uniformity,
Stand on pasture ridge-lines that Joe's steers once followed.

COUNTY LINE ROADS

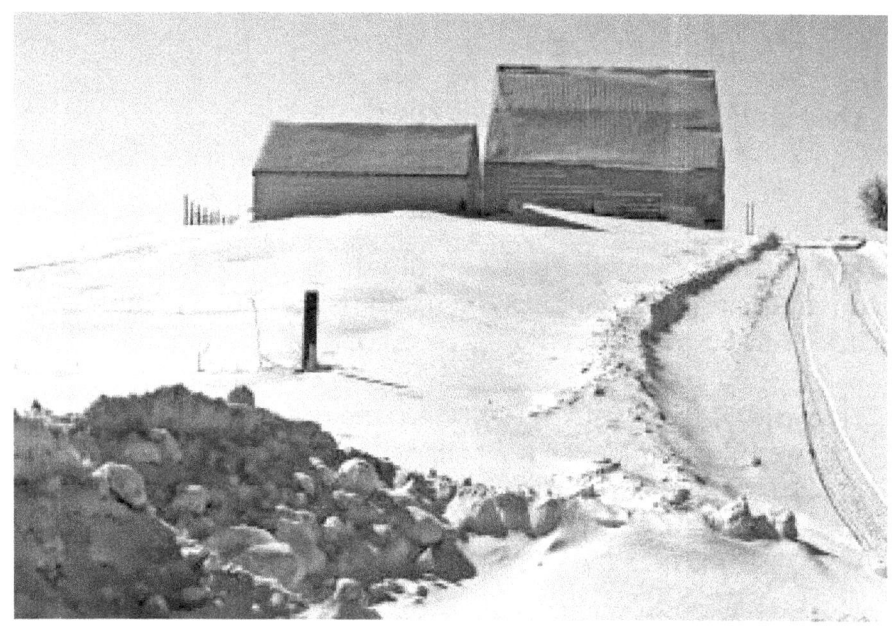

BLIZZARD

It wasn't the first time Danny had experienced this.
He nursed his aging Kenworth east-bound out of Nashua.
Heavy snow started blasting across his hood.
A load of soybeans for Clayton Terminal filled his trailer.
As the wind picked up, he couldn't even see his radiator cap.
Danny put on his flashers and crawled along.
Gingerly, he judged his distance from blacktop edges.
Appearance of an empty farm lane to pull into gave respite.
He eased to a stop in a swirl of snow and hissing air-brakes.
Soybeans didn't have sure deadlines anyway.
Why risk it?
His thermos was full, as was his pail of sandwiches.

BOB NANDELL

He spent his night yakking with other drivers on CB radio.
Danny knew what it felt like to be trapped by weather.
He knew when to call it quits and stop driving.
It was better than ending up on his side in a steep ditch.
Danny knew what forty-mile-an-hour wind could do to snow.
He thought about young bucks trying to keep going on I-35.
Danny knew that time and experience was not on their side.
His other business, a towing service, would be busy tomorrow.

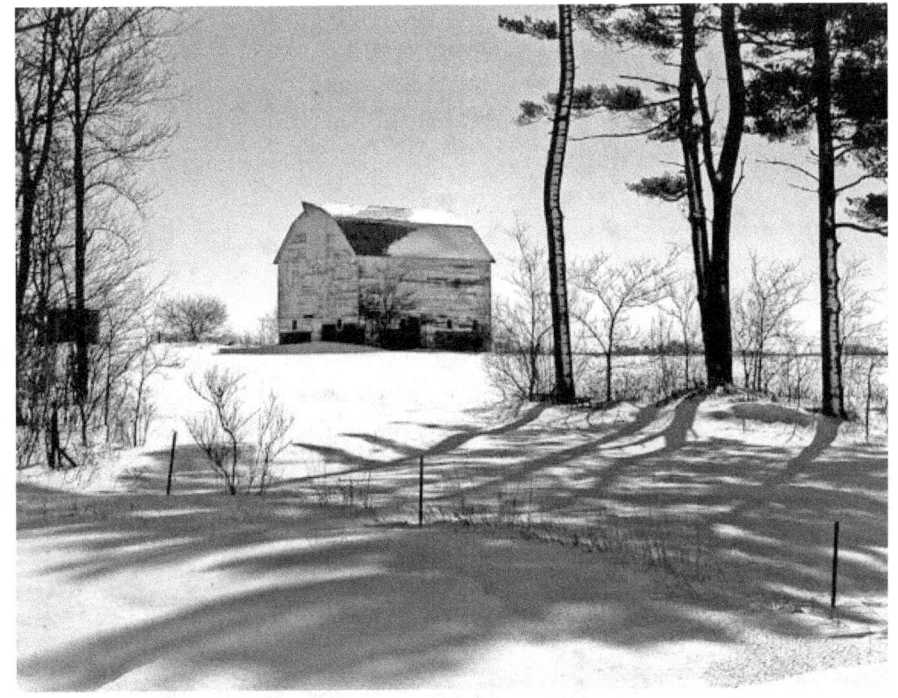

BLUE SPRUCE MOTEL

There wasn't a blue spruce tree within miles of Marci's motel.
She named it after a place she and her husband once stayed at.
Business was pretty good for a time after she bought it.
Autumn brought pheasant hunters and
 winter brought deer hunters.
Summer saw farm workers, traveling salesmen,
 and vacationers.
Winter blizzards brought motorists wishing for shelter.
Marci knew when locals wanted a room for a one-night stand.
She would give them a spot in back, away from the highway.
Marci had seen everything from field hands to
 gentlemen in fine suits.
She once let a mother and four kids keep a room
 free for a month.
They had nowhere else to go after being evicted
 from their apartment.
Marci kept her office and lobby bright and cheerful
 with potted plants.

BOB NANDELL

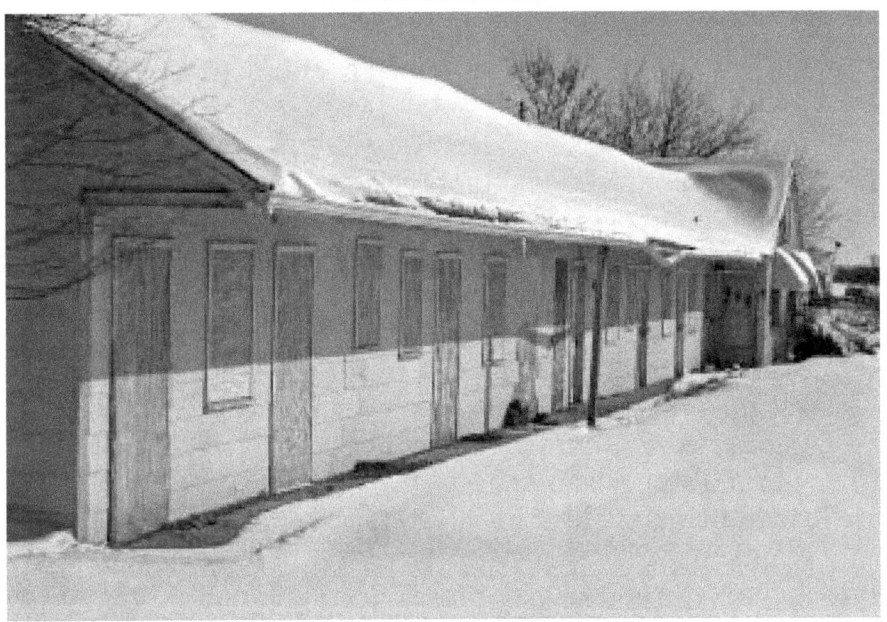

Blue Spruce Motel featured faded 1950s furniture
 and clean beds.
Every morning Marci rolled her laundry cart
 from room to room.
She found lost clothing, empty whiskey bottles,
 and newspapers.
She once found a loaded shotgun somebody
 left under a dresser.
Marci never talked much about her place
 except to gripe about upkeep.
Business started fading along with other town businesses
 in the 1990s.
What ended things was an Interstate Highway link
 built ten miles east.
No one wanted to stay at a faded old motel when
 new ones were closer.
Marci's town and her motel were left stranded
 like a boat on a beach.
She keeps a color picture of her motel framed
 on her kitchen wall.
She likes to remember what Blue Spruce Motel was like
 in its prime.

CATTLEMAN

Earl McCall raised a fine herd of registered Angus steers.
He did it without ever owning his own piece of ground.
For years he rented scattered land parcels
 others deemed worthless.
He knew his herd was exceptional, sleek, and beautiful.
It took several decades of careful breeding to reach their peak.
Markets in Fort Dodge weren't paying top dollar to anybody,
So Earl decided one humid August morning
 to cull six of his best.
He loaded them into his rickety old farm truck
 and headed for Chicago.
It took two days and two quarts of 30-weight motor oil
 to get there.
He fed and watered his prized animals all along the way.
He even stopped to let them graze in some roadside ditches.

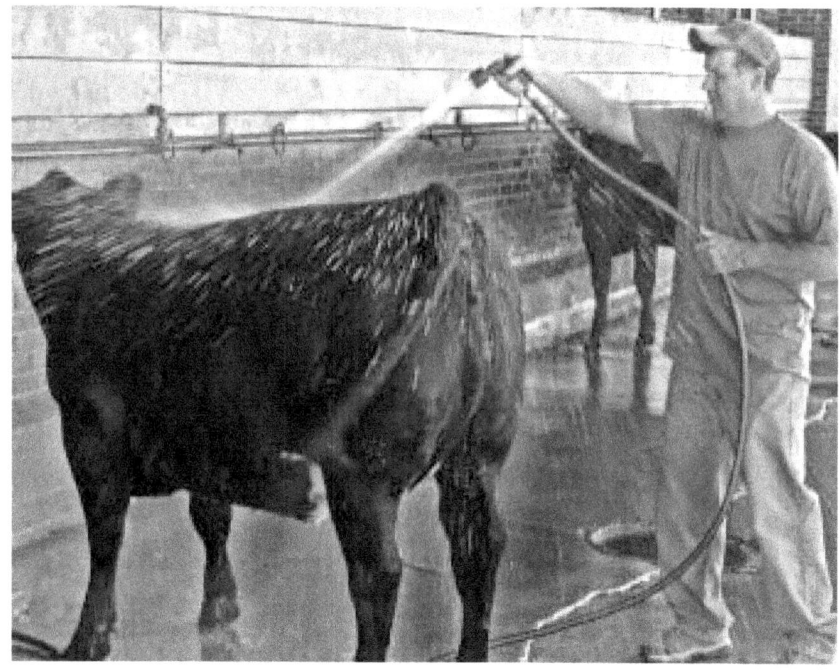

BOB NANDELL

He and his wife slept in the truck cab
 through a sweaty summer night.
Cattle buyers couldn't believe what they were seeing.
These were no skinny Texas grass-eaters
 shipped on the Illinois Central.
These were huge, corn-feed steers tipping scales
 at over a ton apiece.
Earl sat quietly smiling as the numbers got
 bigger and bigger and bigger.
These steers would end up on dinner plates in
 Chicago's finest restaurants.
Earl wouldn't accept any city slicker's bank check either.
He took payment in a wad of twenties, fifties, and hundreds.
It was quite a sight when, clad in bibs and dusty boots,
 Earl took his wife
To supper that evening at one of
 Chicago's stockyard steakhouses.
Two days and two more quarts of motor oil later,
 they made it home.
Earl marched into Walker's bank next morning
 and paid off his loans.
Two days later, a cattle buyer came to Earl's house,
 checkbook in hand.
Earl silently listened to numbers being offered
 for his remaining herd.
He resolutely held up his Chicago sales receipt.
Such numbers had never been seen anywhere
 in Greene County.
Earl got top money. He became a bank stockholder,
Lived to be 92, and got his dividend checks
 every June and January.
Earl liked to show off a tattered old photograph
 he kept in his wallet.
It showed a row of six prize steers he had once hauled
 to Chicago.

COUNTY LINE ROADS

CHIEF

Chief Mahaska would laugh himself silly if he only knew.
A whole county of rich, productive farmland
 was named after him.
Generations of solid German and Dutch immigrants
 made their
Fortunes breaking sod of that land, raising crops and cattle.
Where Chief Mahaska once hunted buffalo, hog farms now sit.
Creeks he used to water his horses have been dammed
 into farm ponds.
Forests he walked through were cut down to build
 blocks of houses.
Chief Mahaska would howl if he saw a
 bronze statue of himself,
Peering westward, over a block of brick business buildings.
Chief Mahaska stands on a town square park
 near a bandstand.
Noon-time loafers sit on benches at his feet, talking chit-chat.
Chief Mahaska didn't have time to sit on a bench for chit-chat.
He had a tribe to lead, children to feed,
 and dwindling land to do it.
Government agents told him where he could and couldn't go.
Settlers, wood fences, and countless plowmen also saw to that.
Look closely at his statue, and see the smirk on his wise face.

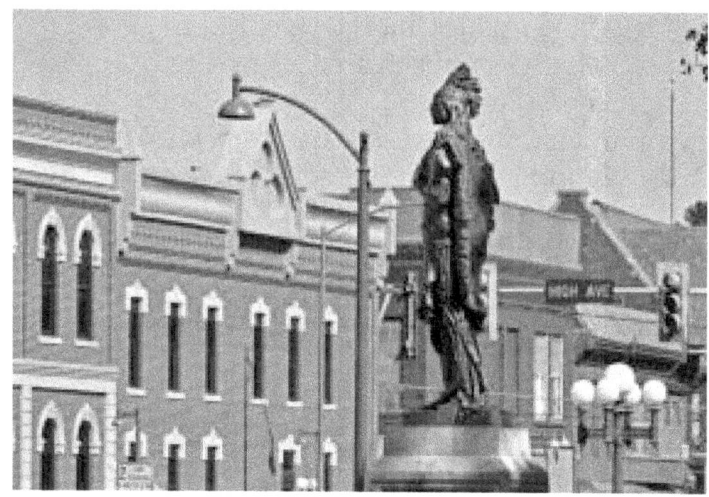

BOB NANDELL

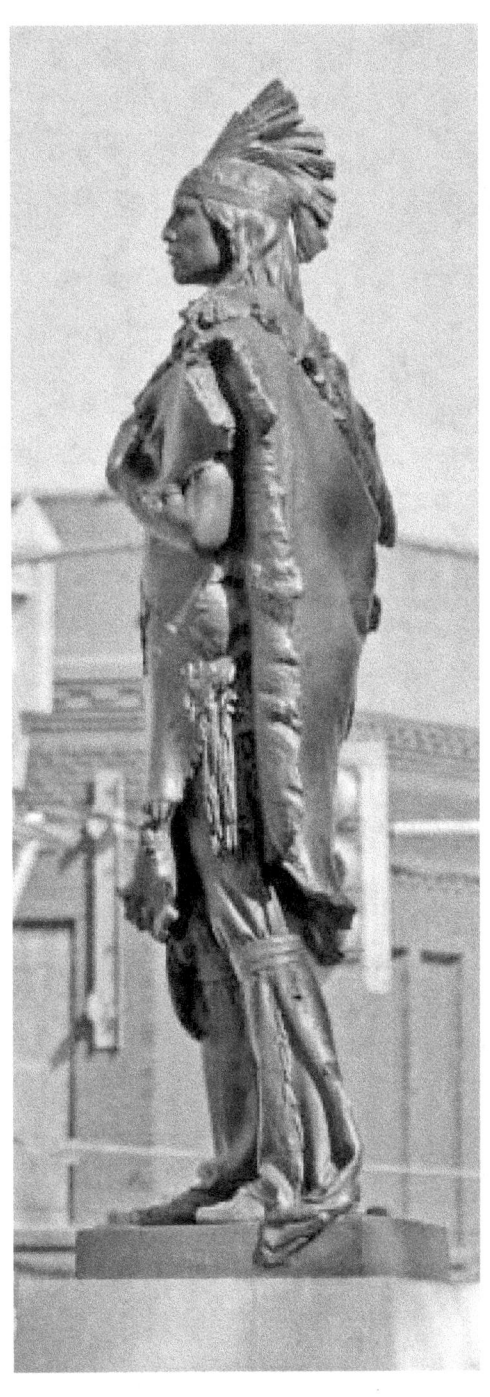

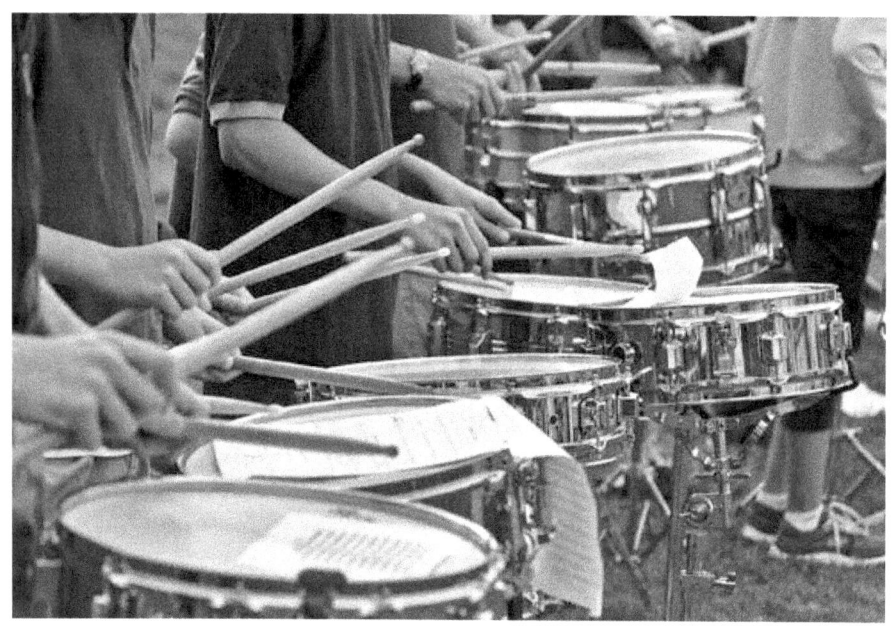

CICADAS AND DRUM LINES

Autumn rituals arrive.
Cicadas sing midst drying August leaves.
Sounds of drum-lines fill cooler mornings.
Fog wafts across County Road B40.
Timid freshmen become sophomores.
Pimpled sophomores become juniors.
Feisty juniors become wiser seniors.
Alma mater songs sound neat.
Cadence patterns echo their beat.
Like endless cycles of life they repeat.
Like harmony of brass, Youth is sweet.
Boom, rattle, rattle, bang, boom, boom!
Semesters and years flash by too fast.

BOB NANDELL

CLARENCE

Clarence was a man of few pretenses.
A passing salesman once observed him getting out
 of his muddy truck.
Clarence was clad in a faded shirt and bib overalls
 with patches on them.
The salesman wondered aloud to barber Jim
 who that poor old soul was.
He watched Clarence walk slowly into Billy's grocery store.
Barber Jim could hardly stifle his laughter.
He knew Clarence owned town municipal bonds.
Clarence could jolly well buy every building
 standing on Main Street.
Clarence kept a big Cadillac sedan with
 yard-high tail fins in his garage.
Every Sunday Clarence would put on his best three-piece suit.
He would park his Cadillac sedan in front
 of the First Baptist Church.
When he got back home he would put his
 ragged bib overalls back on.
He would drive his rusting wreck of a pickup
 out to check on his crops.
Clarence owned several square miles of
 rich black farm ground.
Clarence didn't believe in showing off like city folks do.

COUNTY FAIR

Who cares if Leon's calf got a red instead of a blue ribbon?
Beef from that critter lasted his family all winter long.
Diane's goose didn't even win a ribbon.
She raised it from a gosling and fed it every day before school.
She endured the beatings from its wings on her bruised legs.
It tasted real good for her family's Thanksgiving dinner.
Maxine's jams and jellies won a nice blue ribbon.
She followed recipe books all spring without her mom's help.
Trial and error in a boiling hot farmhouse kitchen paid off.
Years later they might live in concrete-lined streets in town.
Their 4-H shirts might be tucked away in their parents' house.

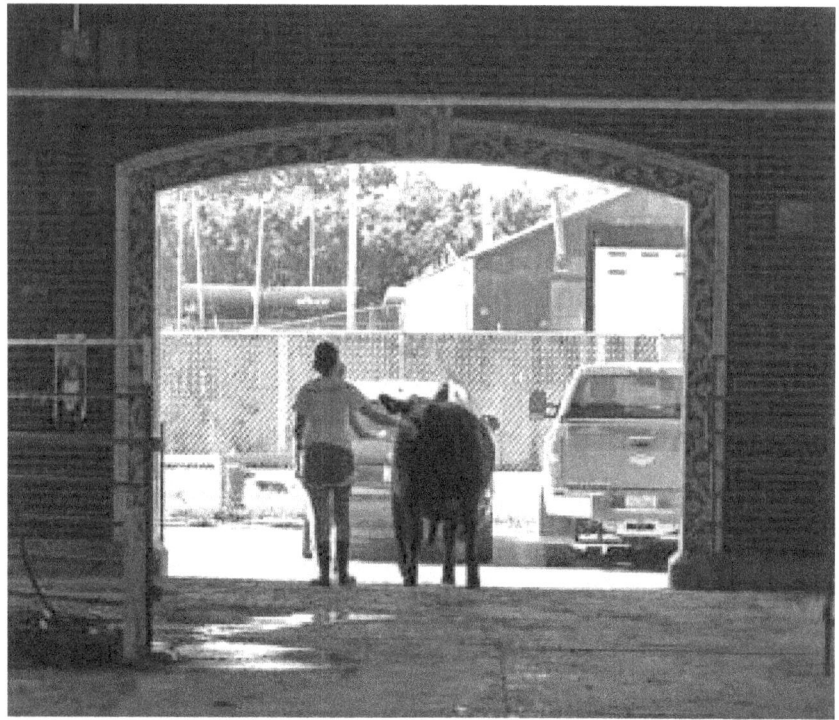

BOB NANDELL

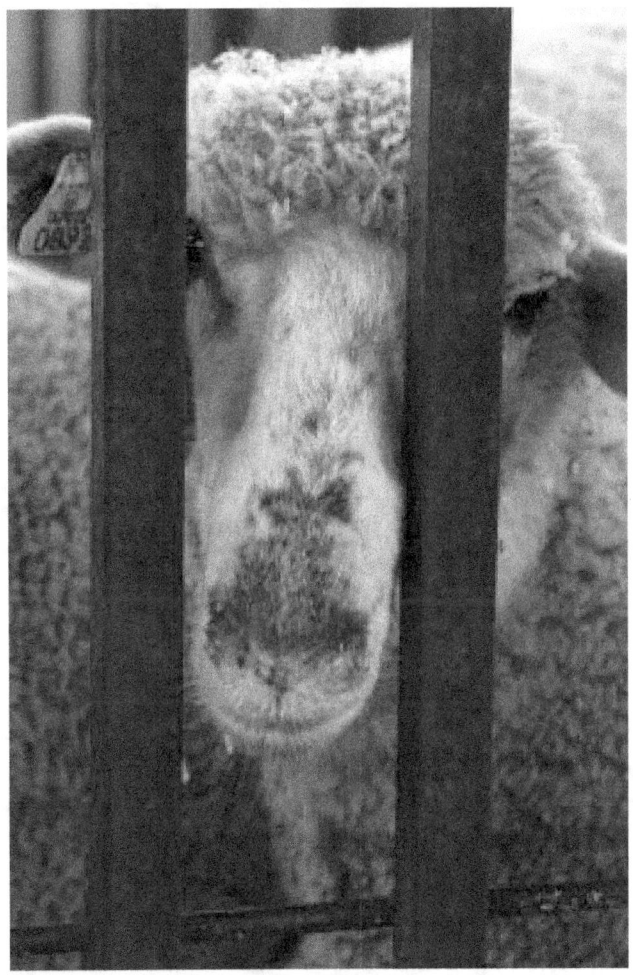

But memories of what pigs smell like,
 of what sheep sound like,
Of how big a little calf grew, of how ornery a goat
 was to show,
Of how hard it was to feed chickens hand-ground corn
 every day,
Of how a farm dog surprisingly responded to commands
 at show,
Of how a batches of vegetables grew big in spite of drought,
Of how a winning sunset photo was made with Dad's camera;
These things will linger in memories when future fairs come.

COUNTY LINE ROADS

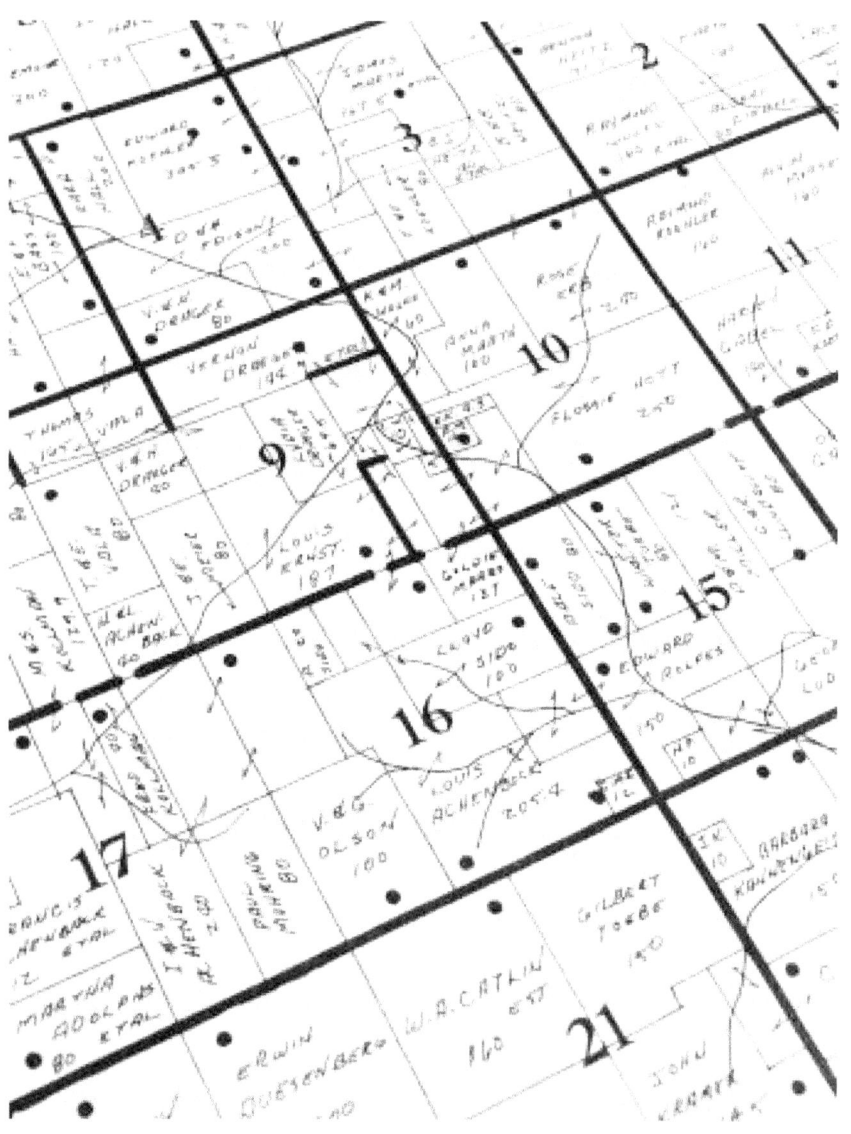

BOB NANDELL

COUNTY LINES

Like quilts sewn in 40, 80, or 160 acre squares,
Marked neatly into townships and counties,
Pioneer generations legally locked themselves in.
Countless paper squares tell of their fortunes.
Wooden shelves hold brittle binders.
Lost stories live deep in courthouse basements.
Labor, gain, loss, divorce, inheritance, division,
All were recorded through times of change.
Quests to own more 80s or 160s than others,
Disaster striking names from a 40 here or there,
Success merging 160s together into 640s,
All things accomplished by names long forgotten.
Nobody remembers names of their children.
Nobody remembers names of their horse teams.
Nobody remembers brands of their first tractors.
Nobody remembers how much corn they raised.
Nobody remembers even how most of them died.
Plat books with tattered pages hold their names.
Plat books in courthouse cellars mark legacies.
Plat books silently keep tales undimmed by time.

COUNTY LINE ROADS

COUNTY ROAD B20

Harold sits in his rusty lawn chair in front of his house.
Some of his grandchild's toys lie scattered around him.
He quietly smokes his pipe and watches grain trucks roll by.
Some truckers, used to seeing him there, honk as they pass.
Harold can tell you if it's been a good harvest or not.
He counts trucks using auxiliary wheels to carry extra loads.
Big rigs laden with soybeans roar past to processing plants.
Some haulers with old, single-axle rigs go to local elevators.
Harold remembers when he didn't have corn to haul to town.
Every kernel was used to fatten Yorkshire hogs at his place.
When big hog confinement operations started moving in,
Harold quit raising hogs and sold corn directly to them.
Harold still likes to fry a big pork steak with some potatoes.
He keeps a big iron skillet on his stove just for that purpose.
Harold gets his pork steaks from supermarkets in Mason City.
He still says ones from his own hogs tasted better back when.

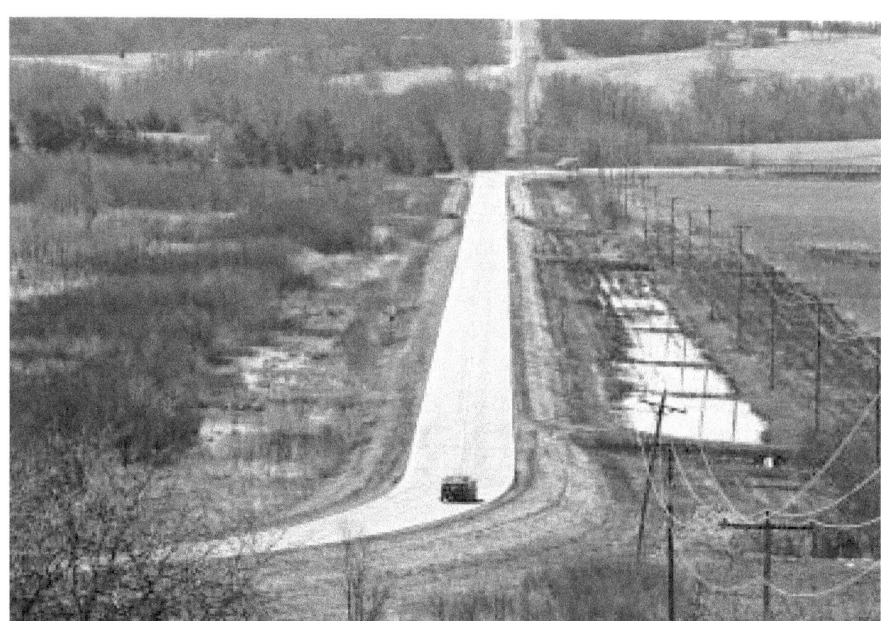

BOB NANDELL

CROCUSES

Every spring he marveled at the tenacity of tiny crocus plants.
Their farmhouse was long gone, only a memory
 locked in old photos.
Someone else now owned and farmed those cornfields
 on County B65.
But every spring a patch of color emerged
 in their backyard in town.
His wife had transplanted a row of crocus bulbs
 by their back porch.
She knew crocus plants would emerge each spring
 after snowmelt.
Delicate blues and purples would spread open
 in warming sunshine.
Their colors flooded back memories for her
 of her farm childhood.
They would bring back memories for him of her after she died.
Simple crocus bulbs, clinging to life beneath snow and cold,
Tender shoots rising as winter slowly leaves rich soil,
Endless cycles of death and rebirth.
Endless cycles of long-lasting love.
Endless memories.

COUNTY LINE ROADS

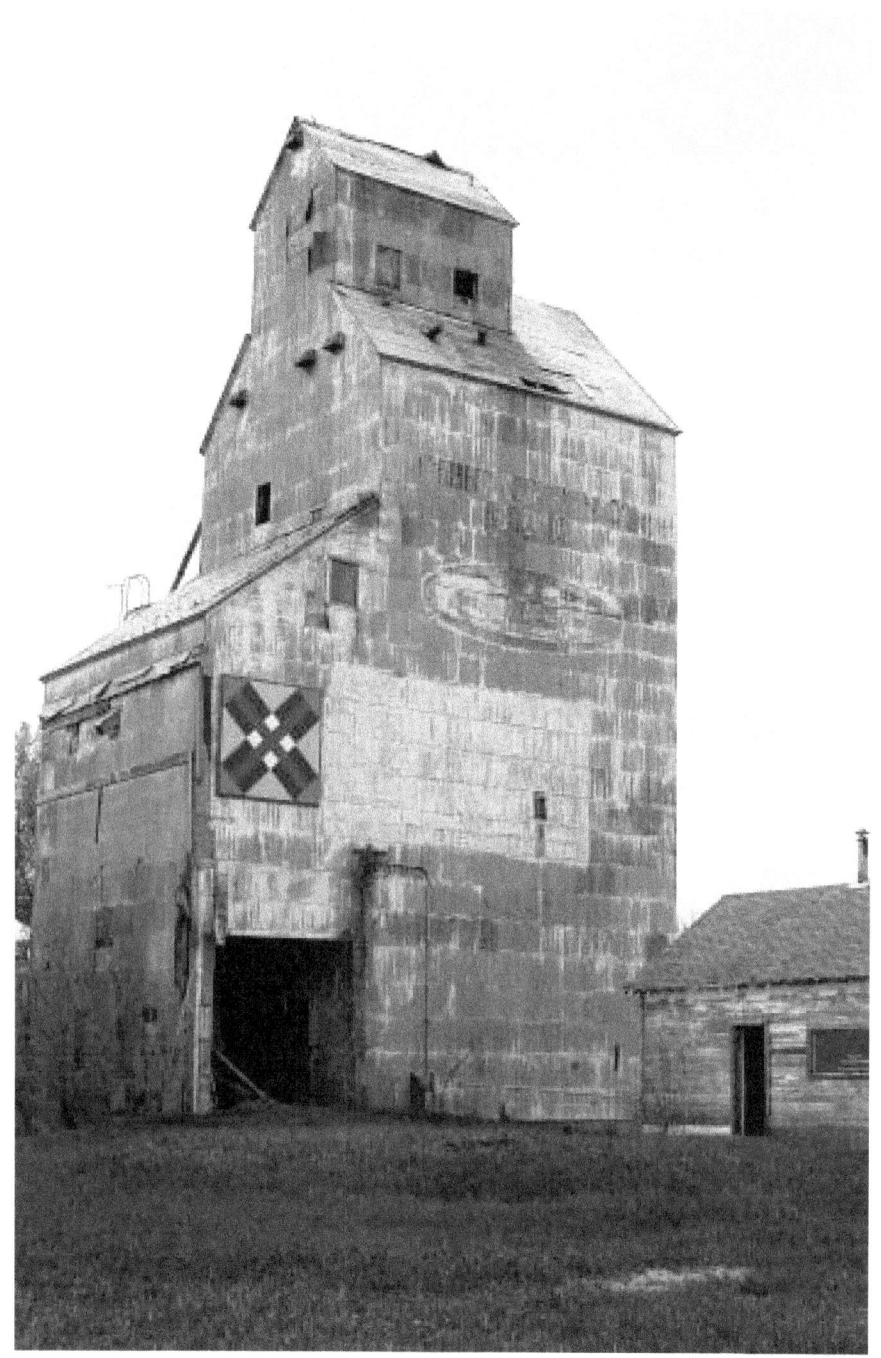

DERELICTS

Rusting sheet metal flaps in endless winds.
Half-rotted timbers groan, straining against summer storms.
Piles of railroad ties lying nearby mark similar abandonment.
Weeds grow across scales that once weighed
 loaded grain trucks.
Thousands of them dotted Iowa prairies in 1950s heydays.
Time, larger farms, and huge grain consortiums ended them.
A couple of them along County C30 marked sites of hamlets.
Only a few houses there mark towns no longer even zip coded.
Trucks roar past hauling grain to terminals ninety miles away.
Business, once done with handshakes and pads of paper,
Is now conducted by computers or even by cell phones.
Some changes came slowly.
Some decisions were sudden.
Some adapted.
Some did not.
Some won.
Some lost.
Some had fates decided in Minneapolis board rooms.
Some had Chicago executives say they weren't needed.
Only wind rattling rusting sheet metal controls them now.

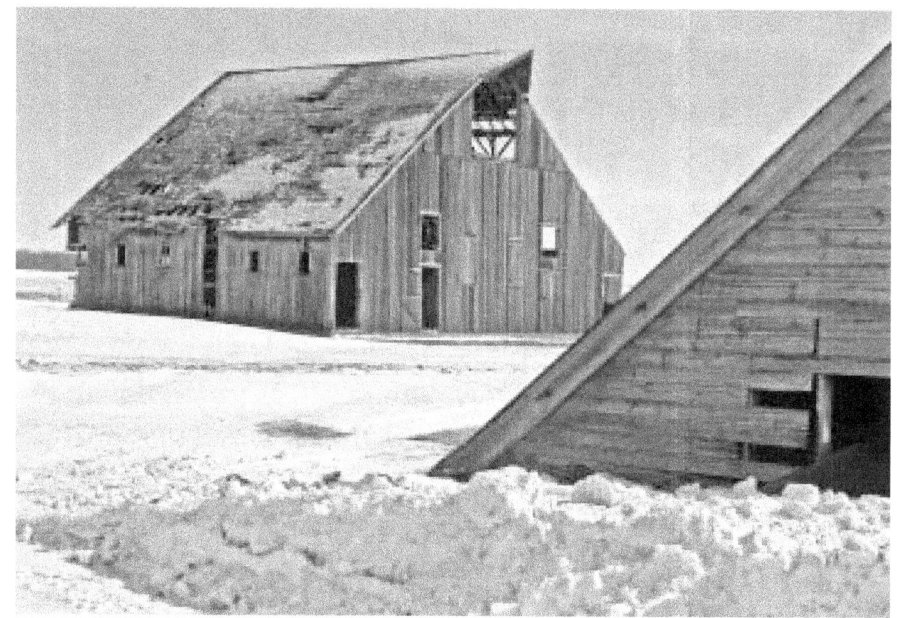

ENDINGS

One strong spring thunderstorm should do it.
A sixty-mile-an-hour gust will leave just piles of boards.
Three stout barns stood for eighty years on Howard's place.
Only this one defiantly stands as a symbol of times past.
There is no need for it anymore.
No more livestock for it to shelter.
No more fencing around it.
No more watering troughs or feed bunks behind it.
No more pasture ground beside it.
It is the only one left standing on County C12 south of town.
Soon a few more rows of corn or soybeans will take its place.

BOB NANDELL

FRESH AIR

Mary always felt sorry for relatives living in cities.
She laughed when she read about a new subdivision rule.
It prohibited outdoor clotheslines, of all things.
Sure, her trusty old clothes dryer had lots of years left,
But summertime at her house meant clothes on the line.
They would smell so extra fresh and clean.
Mary couldn't understand why people want to live
Where they're told what color their siding has to be,
Or what kind of window décor is permitted.
She was thankful to still be living in her same old house
Five miles south of town on County F10.

HERMAN'S HIGHWAY

The name stuck.
"Herman's Highway."
Among some old timers, it still does.
Herman pulled a fast one back when he was
 a county supervisor.
Twelve miles of County F20 were paved in
 gleaming white concrete.
They lead from east of town right up to Herman's farm.
That new piece of road was straight as a rod.
Herman didn't have to worry anymore about his grain trucks
Getting stuck on soggy road shoulders at fall harvest.
He didn't have to worry about getting cattle trucks to and fro.
He didn't have to worry about getting machinery to his fields.
That new piece of road is straight as a rod.
It runs right up to the Floyd County line.
Then you're rolling on gravel again.

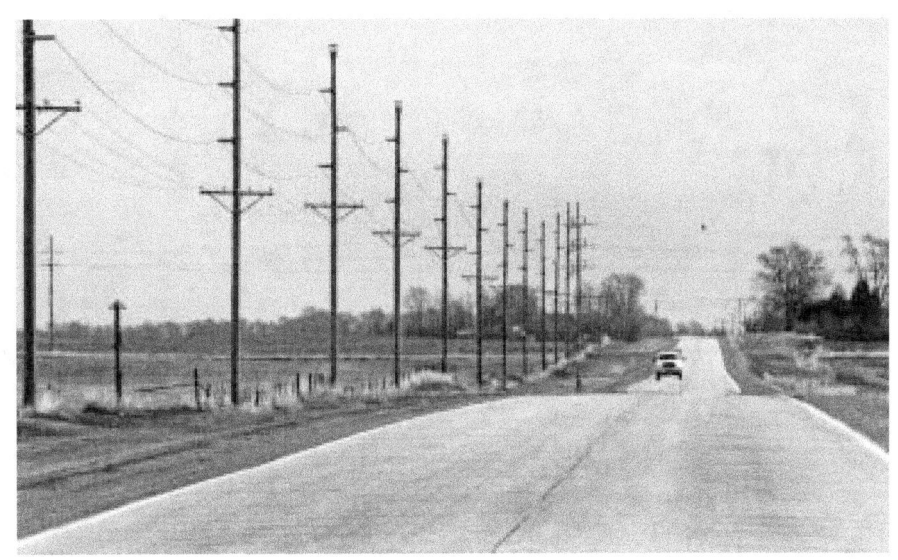

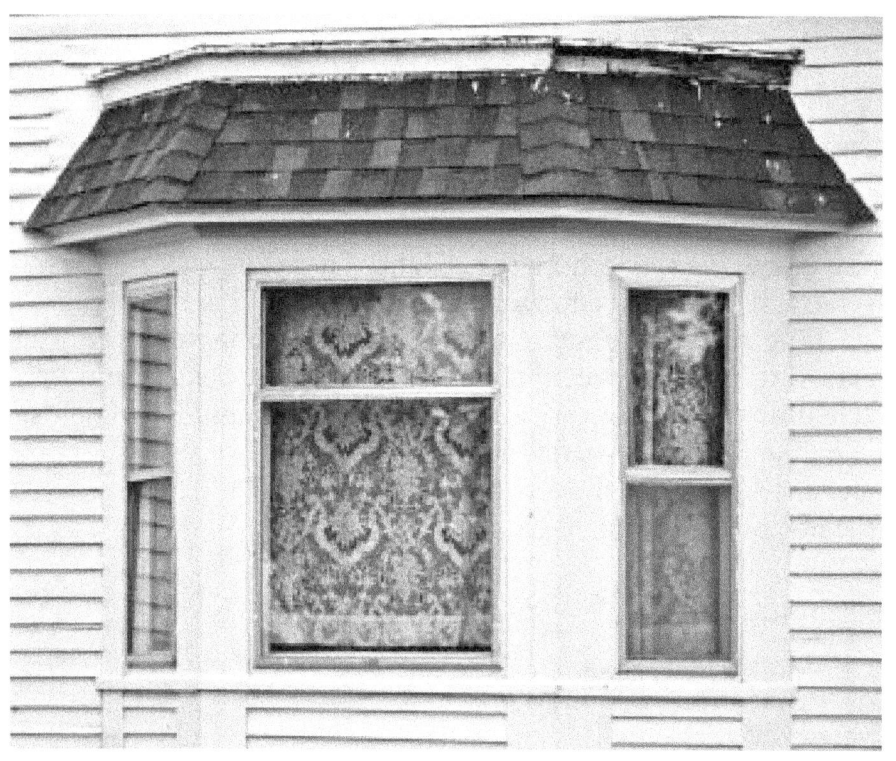

BOB NANDELL

LACE CURTAINS

Velma saw those lace curtains in a Sears catalogue.
She didn't care what her husband Terry thought.
She didn't give a damn what they cost, either.
If folks in nice houses in big cities could have them,
She could have them in her farmhouse windows too.
She happily tore down sun-faded drapes one Monday,
When a box from Chicago was delivered to her door.
Velma ironed out wrinkles, found some brass rods,
And hung those curtains in her living room windows.
It was a matter of pride.
If Terry could drive a Buick, she could have lace curtains.
Fair was fair after forty years of back-breaking work
Helping him raise cattle out on County Road D20.
Velma is gone now, but her curtains are still there.

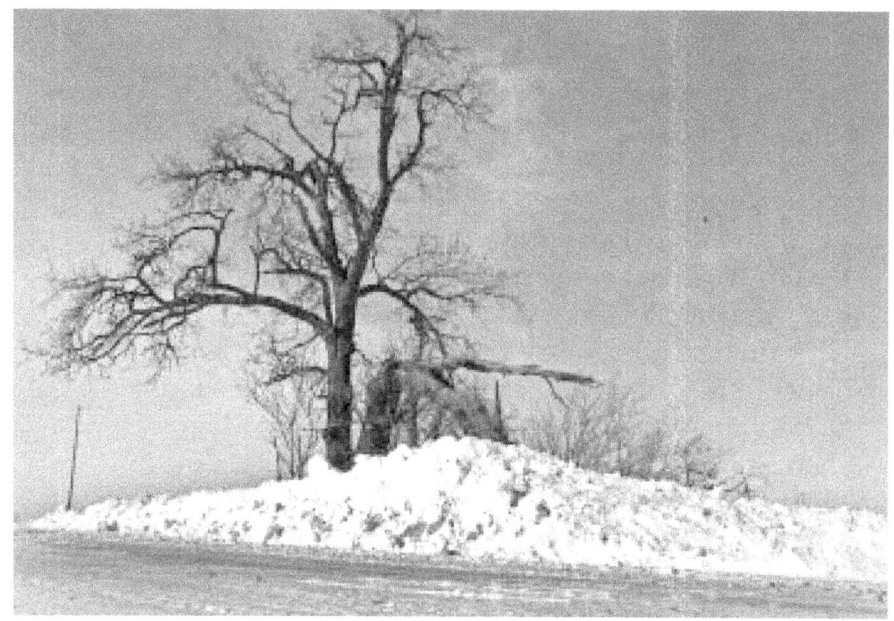

LAST ONE STANDING

Only one weather beaten huge tree stands as a marker.
For a century where Roy's farmstead once stood
There was a grove of them, standing tall and proud.
But summer thunderstorms and winter blasts tore them down.
There used to be a two-story farmhouse, a grain bin,
A chicken coop, a hog house, and a big red barn.
There used to be a vegetable garden, and a single stall garage.
All those are gone now too.
A quarter-section farm couldn't survive modern agribusiness.
Only one huge weather-beaten tree now stands as a marker.
Corn or soybean rows march right up to its base.
A winter storm split off a big branch last winter.
But it stands, defiant, waiting for another springtime.
Perhaps it will last another season of harboring bird nests and
Squirrel families, offering shade for other small creatures.
But its survival odds dwindle with each passing year.

BOB NANDELL

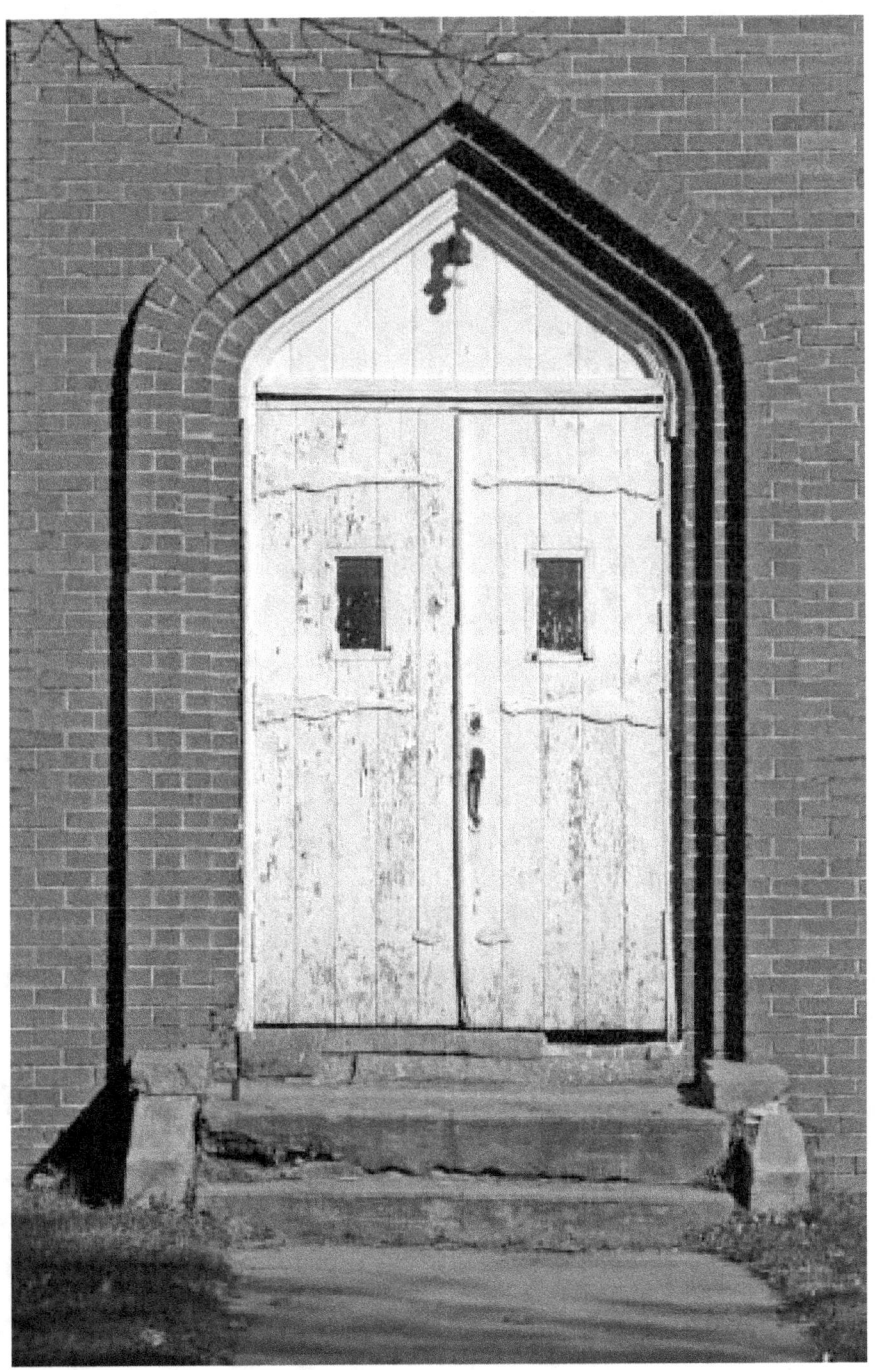

COUNTY LINE ROADS

BOB NANDELL

LEGACY

To financiers in New York City, it's only rows of numbers.
To others it's just boring black dirt stretching to far horizons.
To some it's thoughts of money from anticipated inheritances.
 In their greed, they have already spent that and need more.
A wise few see it as something there is only so much of.
No more of it can be created.
Only that which is already here can be used.
Only that carefully tended can be preserved.
It is black soil, rich and deep.
It springs countless plants towards damp skies every spring.
It gives of itself a thousand times over each autumn harvest.
It is black soil, rich and deep,
Upon which those who guard its legacy toil.

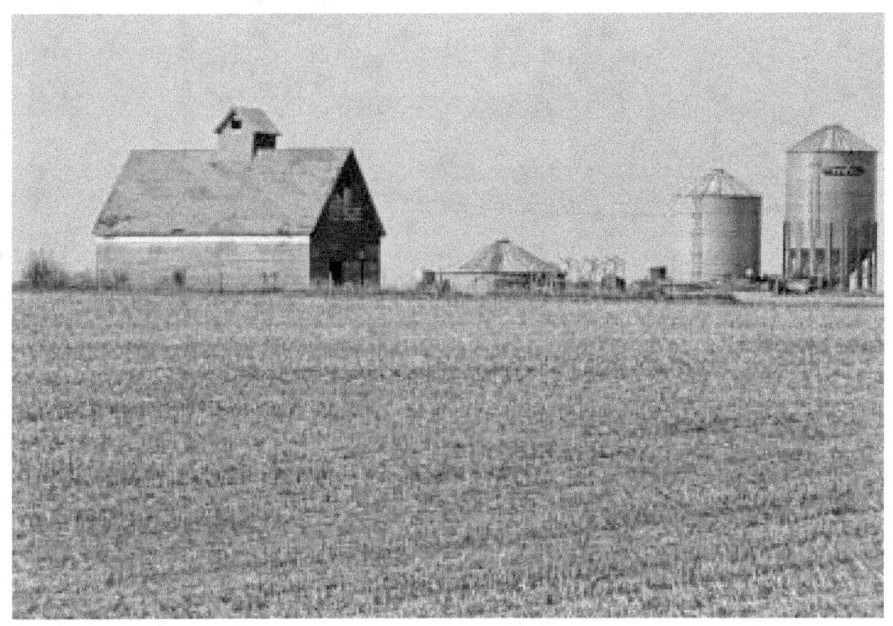

COUNTY LINE ROADS

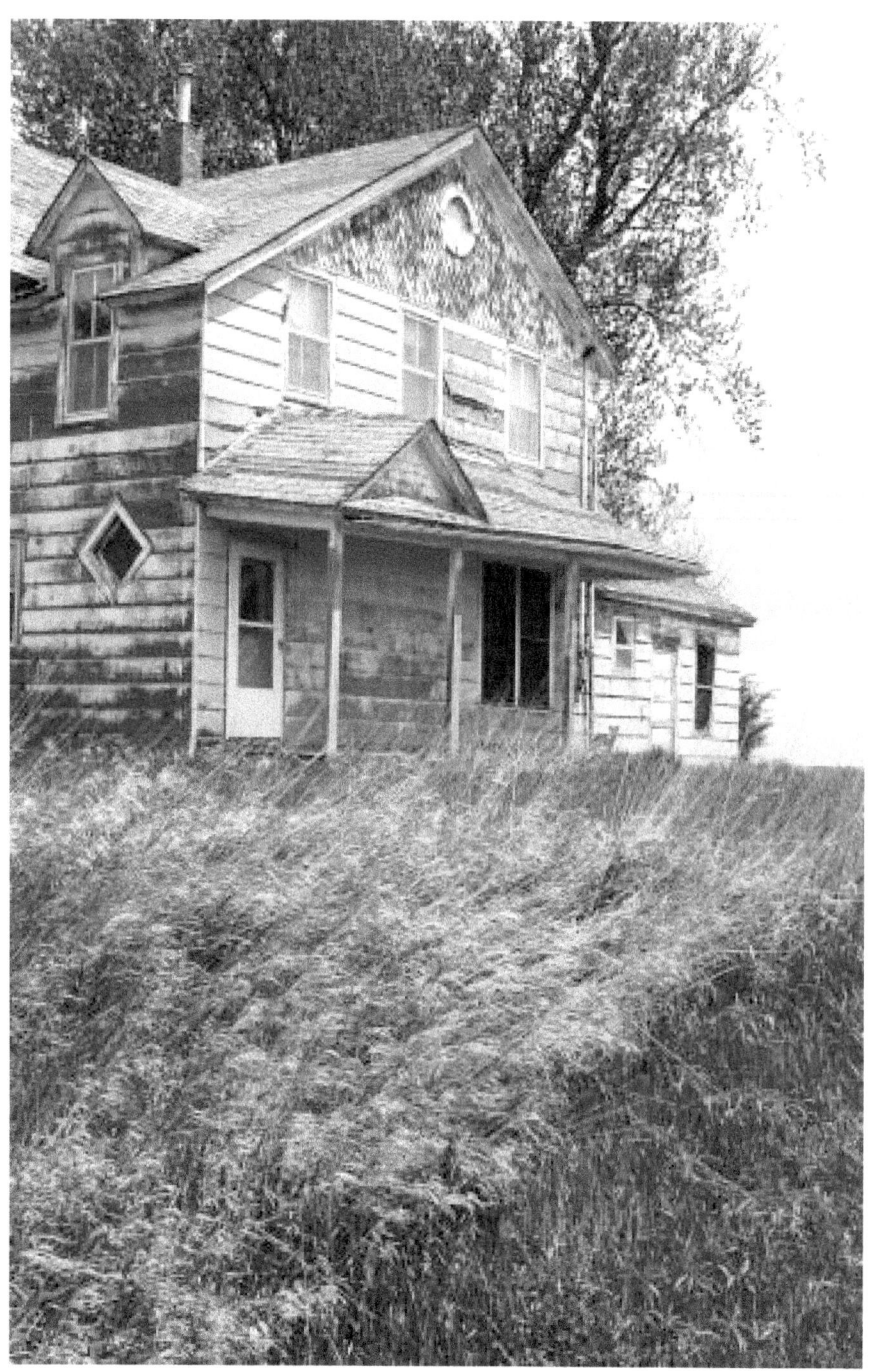

BOB NANDELL

LEONA'S ACRES

Life had not been kind to Leona.
Her husband died of a sudden heart attack.
Her son was killed in a tractor roll-over accident.
Her daughter moved a thousand miles away to California.
But Leona never complained.
Twenty years more she ran their farmstead by herself.
Time and age caused her to sell off a parcel here or there.
Leona always looked out for herself and her daughter.
Leona was a fixture at Methodist Church quilting parties.
She served for years on a library board in town.
She cooked at every community center dinner.
She helped out at every American Legion July steak fry.
Leona loved her house and eighty acres out on County C10.
She stayed busy selling everything from eggs to sweet corn.
She drove little John Deere tractors her husband had left her.
Leona never looked back. She just kept going.

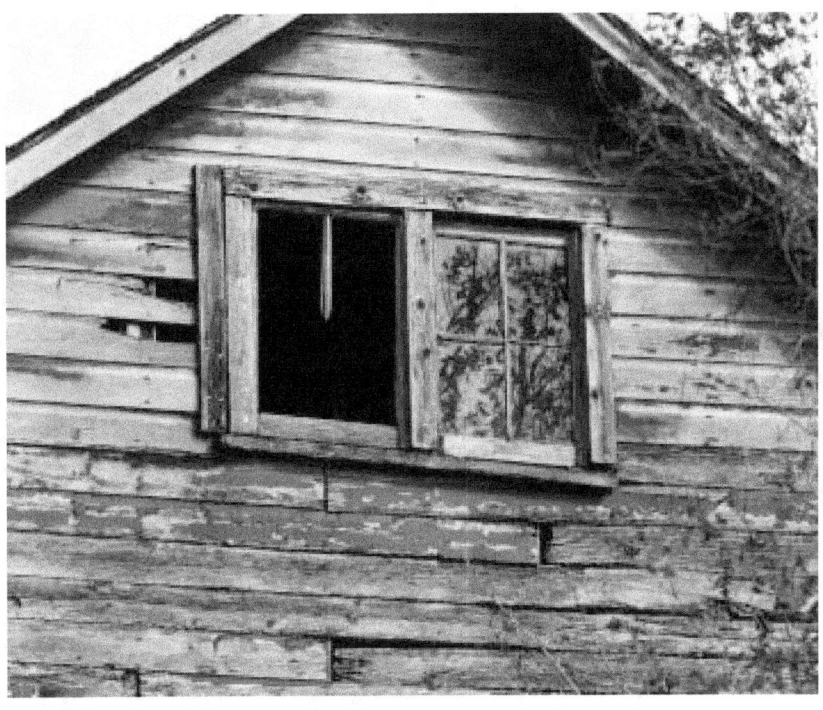

LESTER'S QUARTER

It was only one hundred sixty acres of dirt
 with a few buildings on it.
Lester had busted his knuckles for years
 raising corn and soybeans there.
Then large-scale GMO beans and ethanol corn production
 became vogue.
Lester's neighbor west of him wanted his quarter section
 on County B40.
Two neighbors living to his east were pestering him for it too.
One morning Lester took the highest bid
 and moved into town.
He marched into his bank, check in hand,
 with a twinkle in his eye.
He split his proceeds between himself and his two children.

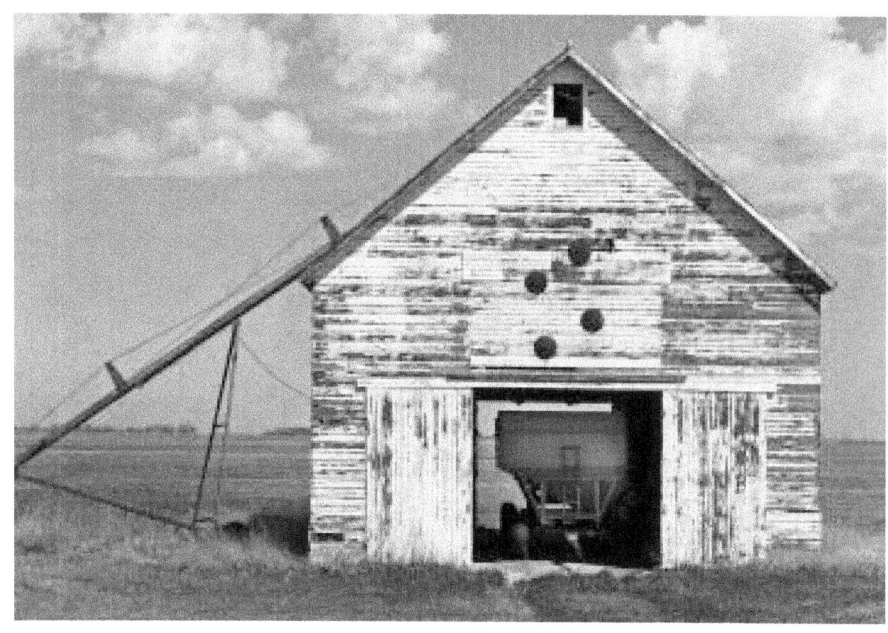

BOB NANDELL

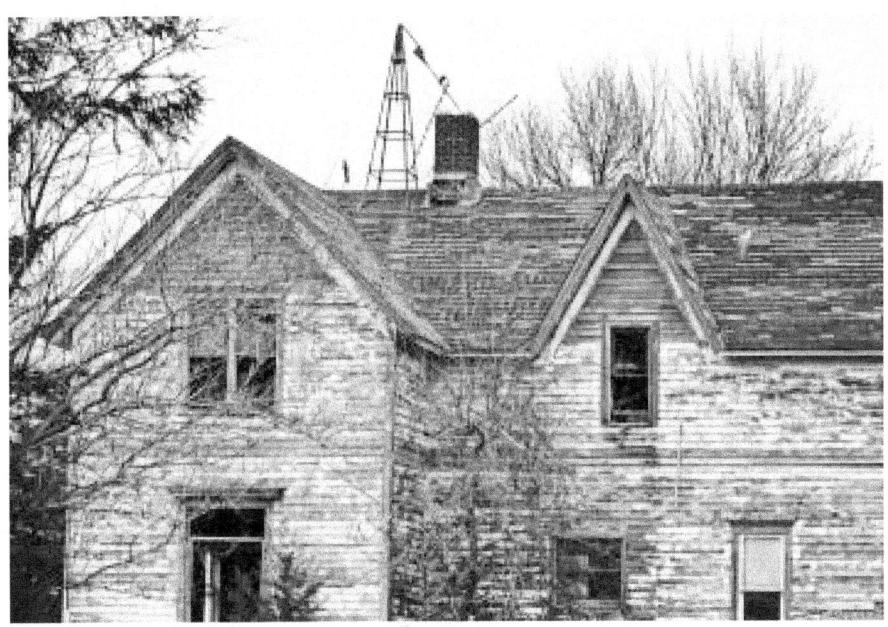

Lester didn't play the stock market with a dime
 of what he kept.
He didn't care how much interest he did or
 didn't earn on it either.
Lester had seen relatives lose their shirts
 playing grain and stock markets.
He had seen people fleeced by big-city brokers
 with their sneaky fees.
Lester ran all offers to invest his money
 through his paper shredder.
He never even bothered to change his meager lifestyle.
He saw no reason to part with a Ford pickup truck
 that still was running.
He willed a hundred thousand for a new community center
 when he died.

COUNTY LINE ROADS

BOB NANDELL

LOCKBOXES

Big-ag locked up surrounding farmsteads.
Hard economic times locked up two taverns in town.
Consolidation locked up elementary school doors.
Corporate decisions locked up a lone convenience store.
All that's left is a row of newly-installed lockboxes.
They stand in front of what once was a post office.
Its paint-peeling doors are locked up too.
Townsfolk drive up to the boxes every morning.
They open their numbered lock box to get mail.
It tells them what will be locked out of their lives next.

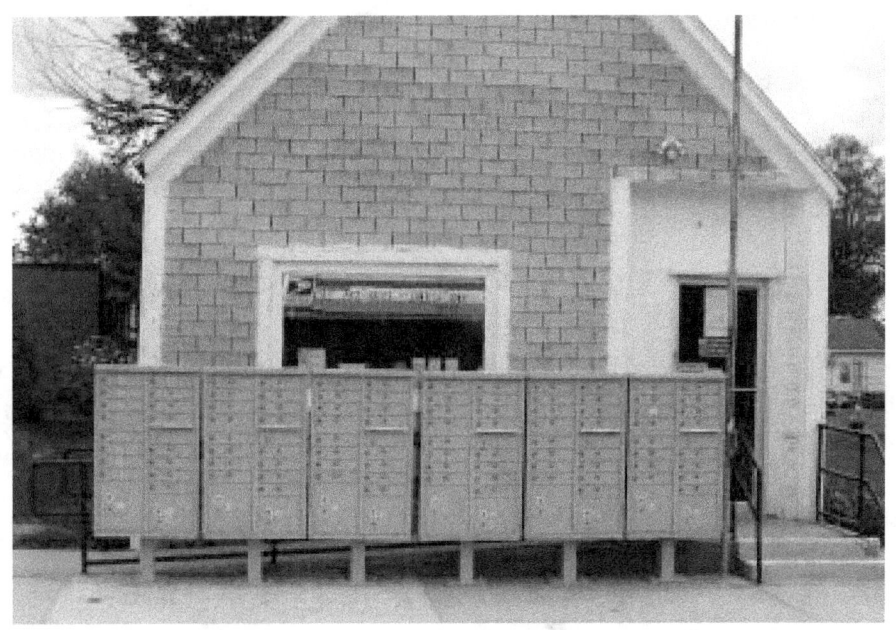

COUNTY LINE ROADS

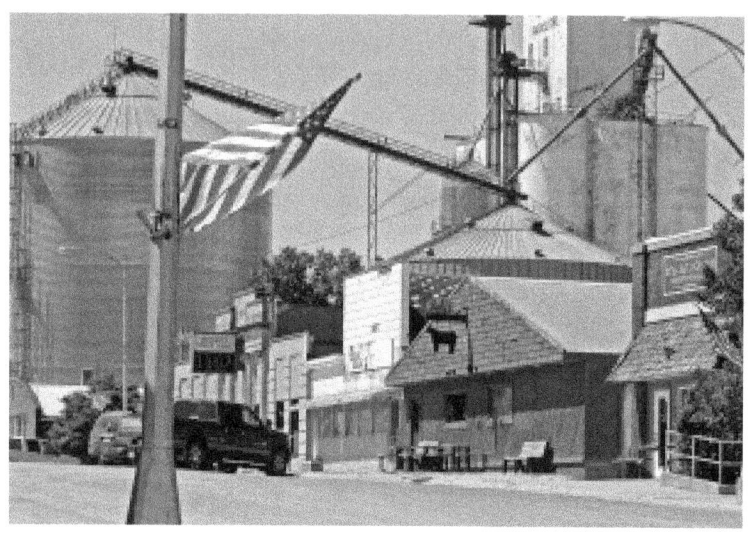

BOB NANDELL

MAIN STREETS

It doesn't take much to change Main Street.
A change in government health care regulations
Can wipe out what was a pharmacy and gift shop.
A change in environmental rules can close a gas station.
A new school bond issue hiking property tax rates
Can shutter a struggling little hardware store.
Death of a spouse can doom a tiny family café.
Decades of prairie winters can wreck brick facades,
And weaken already sagging wooden roof beams.
What once was a state highway through town
Is now a lesser-maintained county line road.
It doesn't take much to change a main street.
Soon nobody's around on a summer afternoon.

MARTIN'S GRADER

Martin kept from going crazy by listening to CB radio chatter.
Mile after mile he smoothed gravel roads with his road-grader.
Every spring he smoothed out ruts and frost boils
 with fresh rock.
Every winter he smashed through drifts
 and cleared intersections.
Every summer he edged county line road shoulders
 with his blade.
Martin remembers bad old days with no air conditioning
 in his cab.
He remembers getting his yellow Caterpillar grader
 stuck in a drift.
It took two trucks with chains to pull his rig free
 from swirling snow.
Martin had wanted to get a college degree and be an engineer.

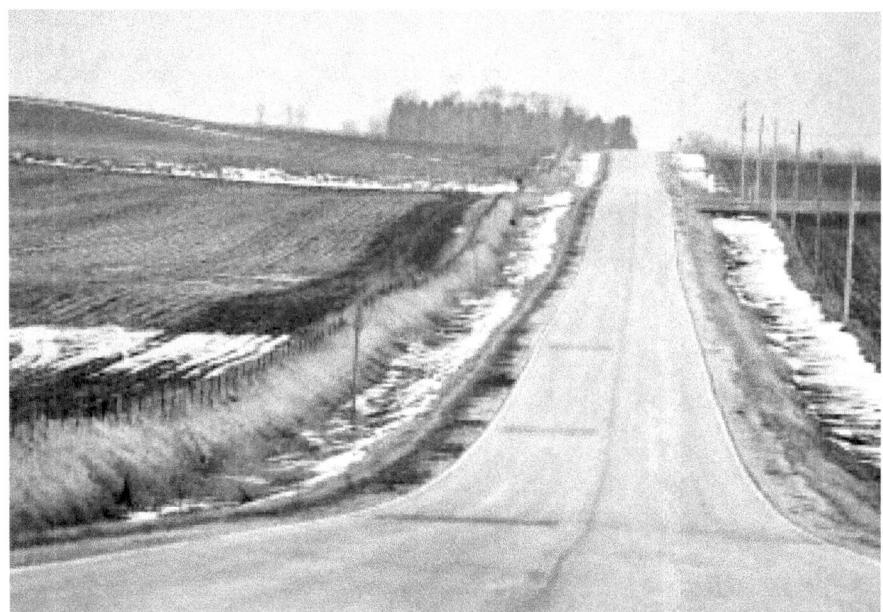

BOB NANDELL

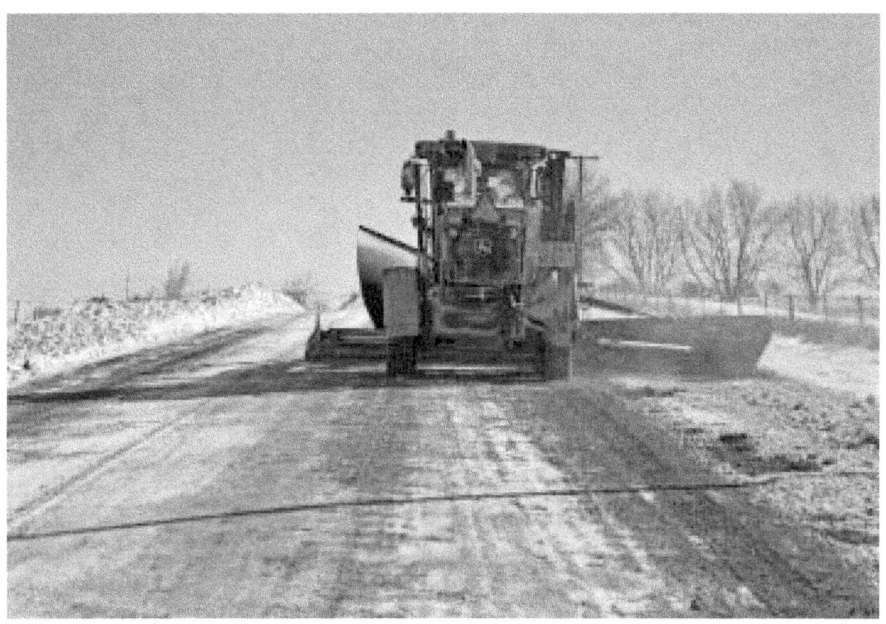

Money, time, a wife, two children, and a mortgage
 decreed otherwise.
So mile after mile, day after day, Martin ran
 his yellow road-grader.
He smiled when his oldest boy loved to play
 with toy road-graders.
He smiled even more when his boy graduated from college.
His biggest smile came when his boy became
 an engineer in Peoria.
Martin was able to retire early from running his grader.
His son made so much money he helped Martin
 make it possible.
Martin runs a gleaming new road grader now. It is a toy.
He and his first grandson push it around
 on his living room rug.

COUNTY LINE ROADS

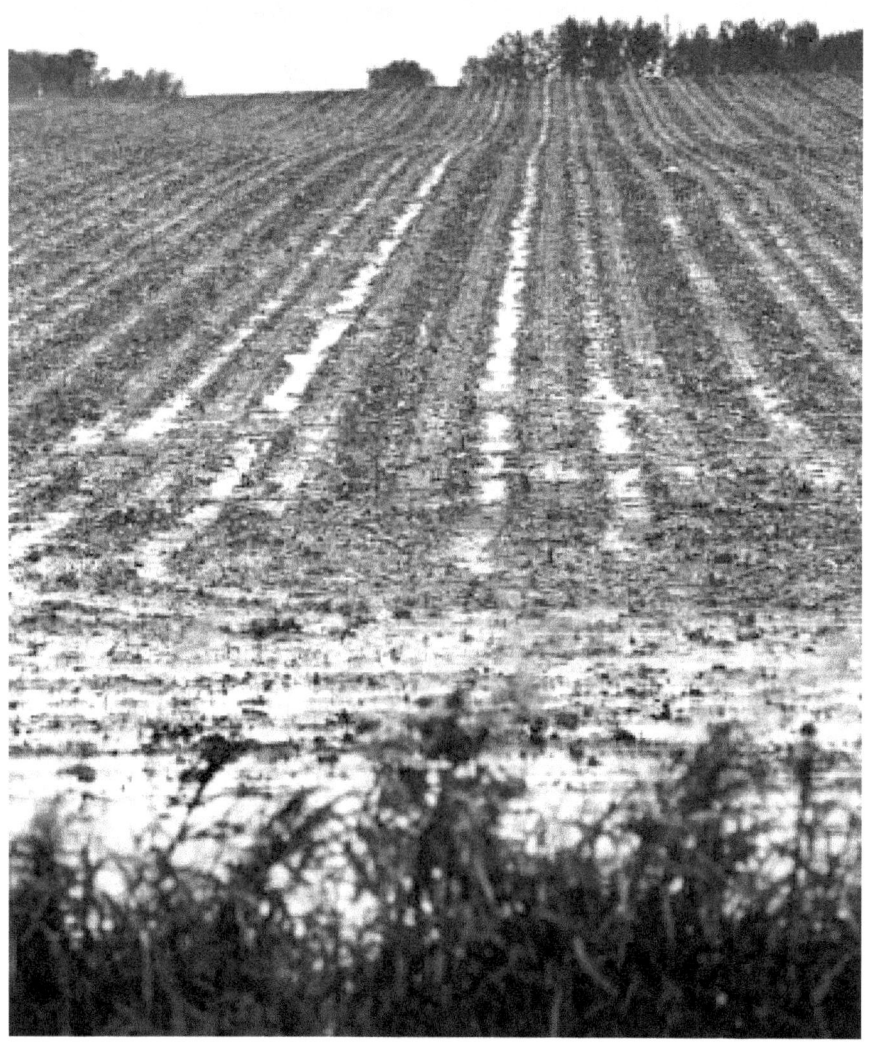

MUD

It wasn't boredom that made him quit farming.
It was mud.
Buster got tired of mud.
It stuck to his boots.
It tracked into his kitchen.
It got all over his coveralls.
It made his ankles itch.
It buried one of his Massey-Ferguson tractors up to its axles.
After one particularly messy spring thaw, Buster quit.
He moved into a ranch-style house in town.
Buster walked into Dralle's Department Store in Greene.
He bought a pair of shiny black Justin Roper pull-on boots
and a polishing pad of mink-oil to shine them with.
He made sure they glowed like a Marine's boots
 every morning.
He wiped them off when getting home from
 walking downtown.
Buster vowed that this pair of boots would never see a feed lot.
Buster just wanted to finally have something clean on his feet.
He wanted those boots to shine better than his banker's shoes.
Buster paid one hundred forty-five dollars for those boots.
Buster never made much from his forty years of farming.
But he felt like a millionaire when he pulled on those boots.

COUNTY LINE ROADS

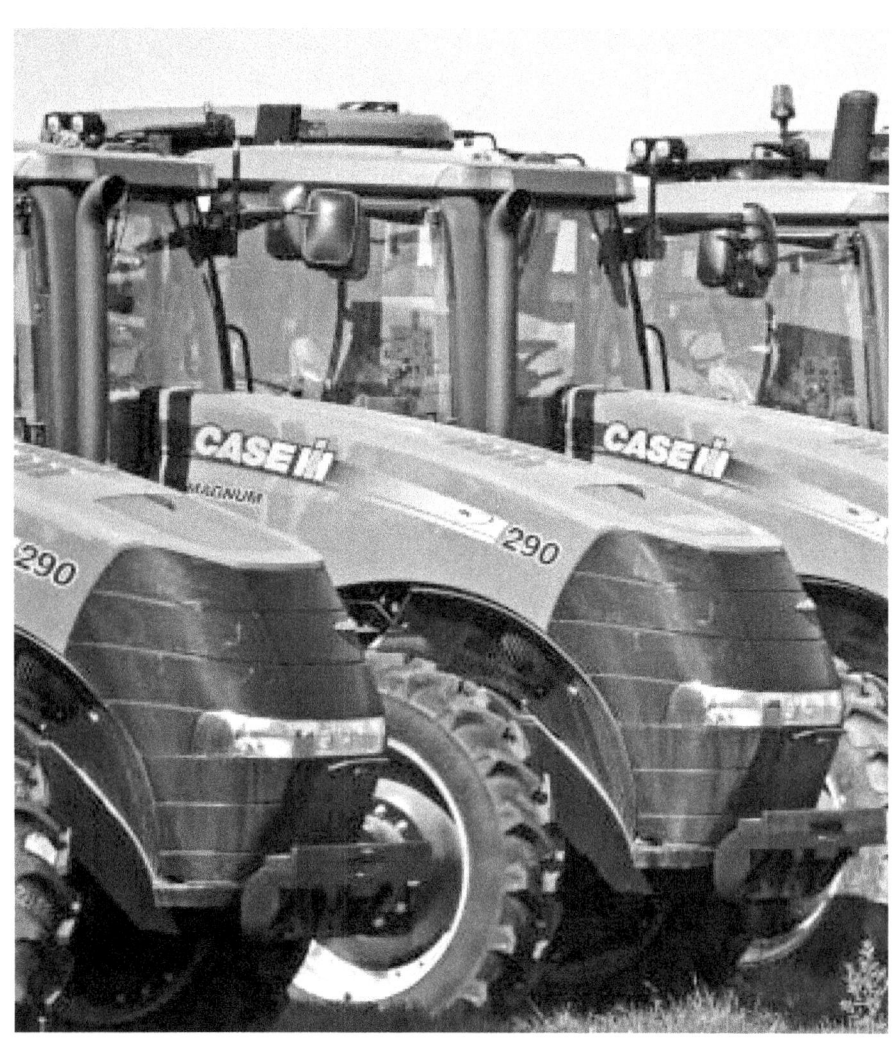

BOB NANDELL

NEW TRACTOR

Old man Linder couldn't believe his eyes.
His grandson took him out to see his new tractor.
It was a doozy.
It had air-conditioning, four-wheel-drive, and even GPS.
It had a diesel engine big enough to pull almost anything.
Old man Linder had sold J.I. Case tractors for decades.
The ones he sold had four cylinders, four gears, and a clutch.
They pulled two-row machinery and hay wagons.
Some of them can be found still pulling wagons today.
Old man Linder climbed into his grandson's new tractor.
He gazed at rows of gauges, buttons, and levers.
He marveled at two-way radio and stereo systems.
He even figured how out to make the power seat move.
He turned to his grandson with a sparkle in his eye.
He asked what the interest rate was on the loan for it.
Old man Linder had never borrowed money in his life.
You could hear his laugher all the way to Minnesota,
As he slowly, arthritically, climbed back down.

NO COFFEE

All of a sudden it wasn't there anymore.
Donny's coffee shop with its pots and platters
 of cinnamon rolls was gone.
What old-timers didn't realize is that all those years
 Donny had been listening.
He heard about crop reports, elevator prices,
 stock market quotes,
Bank buyouts, land transactions, new pickup trucks,
 and cattle futures.
Donny chuckled about how retirees with little income
 left the biggest tips.
He knew which braggarts actually owned land
 and which ones rented.
Donny had paid off his building on Jefferson Street years ago.
Before it became ecologically popular and
 politically smart, when it was still risky,
Donny bought ten percent of a start-up ethanol plant
 thirty miles away.
Once corn started coming in and railroad cars of ethanol
 started going out,
Donny didn't have to worry about crop reports
 and stock market quotes.
He still lives in his same little house on County B13.
He still drives the same Chevy with fading paint on its roof.
He still writes a big check to St. Mary's Catholic Church
 once a year.
Donny doesn't worry about crop reports
 and stock market quotes anymore.

BOB NANDELL

NO MERCY

Where does God's mercy go when thirty mile an hour winds
Howl across open fields and it's ten below zero?
Where is mercy when an axe has to be used to clear frozen
Stock-watering tanks after electric lines go down?
Where is mercy when jammed feed wagon augers
Mean a half-ton of feed is unloaded with a scoop shovel?
Where is mercy when twelve-month operating loans,
With interest owed to banks in far-off cities, come due?

BOB NANDELL

COUNTY LINE ROADS

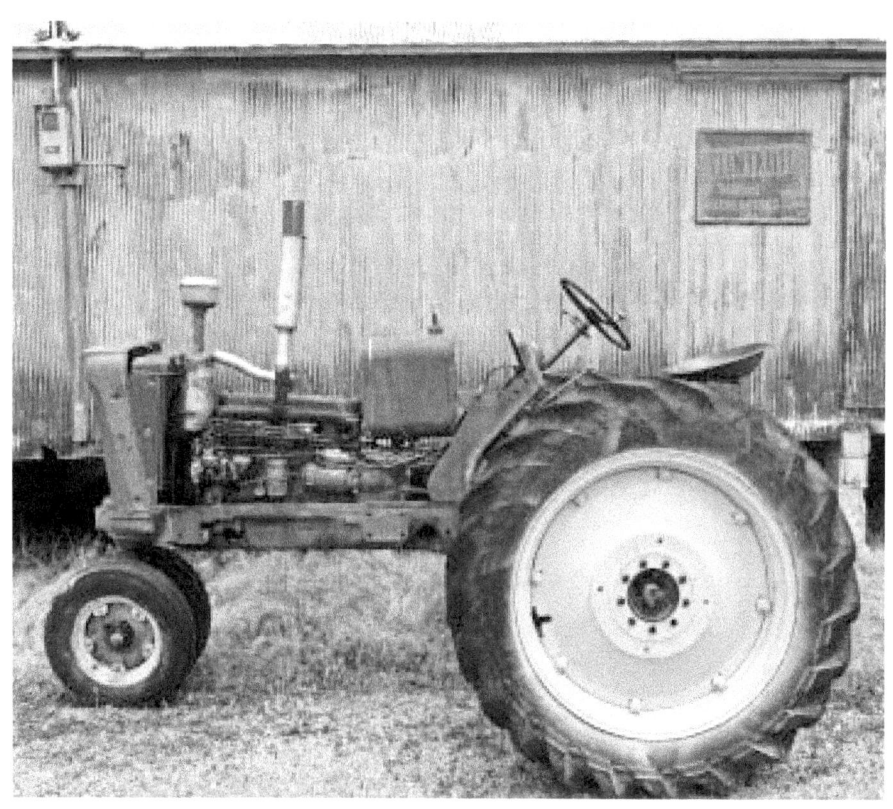

BOB NANDELL

NUMBERS

Robert was good at numbers.
He could do multiplication and division in his head.
He could figure gear ratios with a number two pencil.
His prized possession was his Pickett slide rule.
He wanted to be a John Deere tractor engineer at Waterloo.
Something called the Great Depression decreed otherwise.
Robert was never meant for farming.
He ended up tilling a hundred and sixty acres
 of north Iowa dirt.
His father left him the place and he had no other choice.
His fine set of German-made drafting tools sat in a drawer.
His slide rule became a proud family heirloom.
He could figure acre yields and bushel weights.
He could figure elevator delivery tickets to the penny.
He wrote it all in tidy rows of numbers in a pocket book.
His wife had no idea what all those numbers meant.
She just knew they always had groceries, even in bad times.
His mind was far away as he planted endless rows of corn.
He was still thinking of gear ratios and blue prints.
He was daydreaming about tractors that never were to be.
A guy in town bought Robert's old John Deere tractor.
He's restoring it to pull floats in city parades.
Robert was never meant for farming.
Robert was good at numbers.

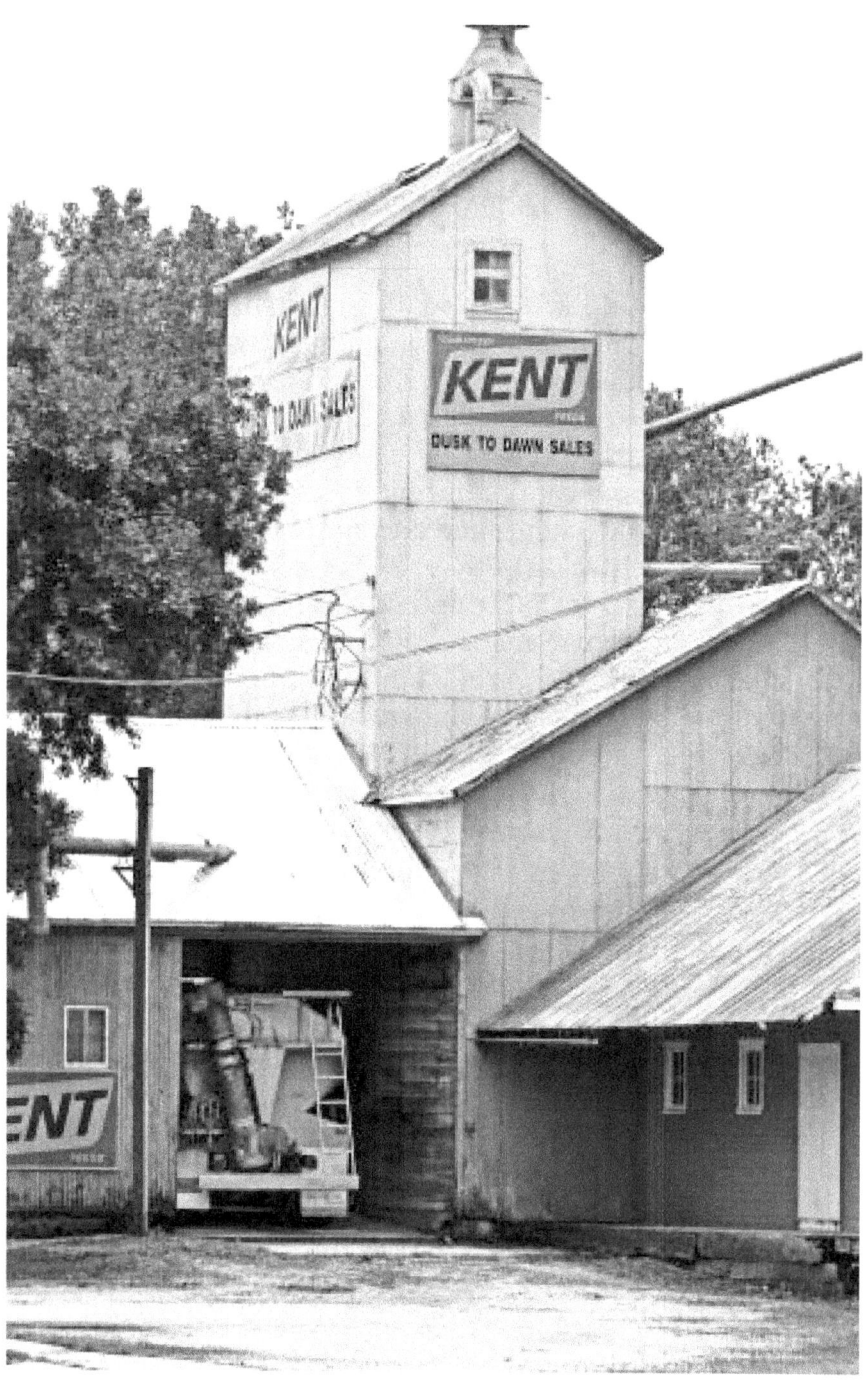

ORLANDO'S FEED MILL

Orlando was always amused.
He couldn't figure out why folks who owned so much
Still sat around complaining so much.
Back in the 1950s things were going pretty well.
Orlando tried to buy the old Willard place by the river.
It had one hundred and forty acres of tillable ground.
But he just didn't have enough cash to make the deal.
So he bought a feed grinding mill in town instead.
For years he delivered hundreds of bags of feed all over
Butler County out of his 1953 Chevy pickup truck.
He sold his mill when cash grain farming took over
And nobody was bothering to raise many cattle anymore.
Orlando sits on the porch of his apartment house
 in Charles City.
He is content to spend hot, hazy summer afternoons
 sitting there.
He listens to radio programs from a station in Minneapolis.
His wife died of diabetes more than forty years ago.
His years of labor didn't leave him many possessions,
But he clings to his trusty green Chevy pickup truck.
No car salesman has ever talked him out of that classic.
He considers his retirement years as "easy living."
Orlando still can't figure out why people who own so much
Still sit around complaining so much.

COUNTY LINE ROADS

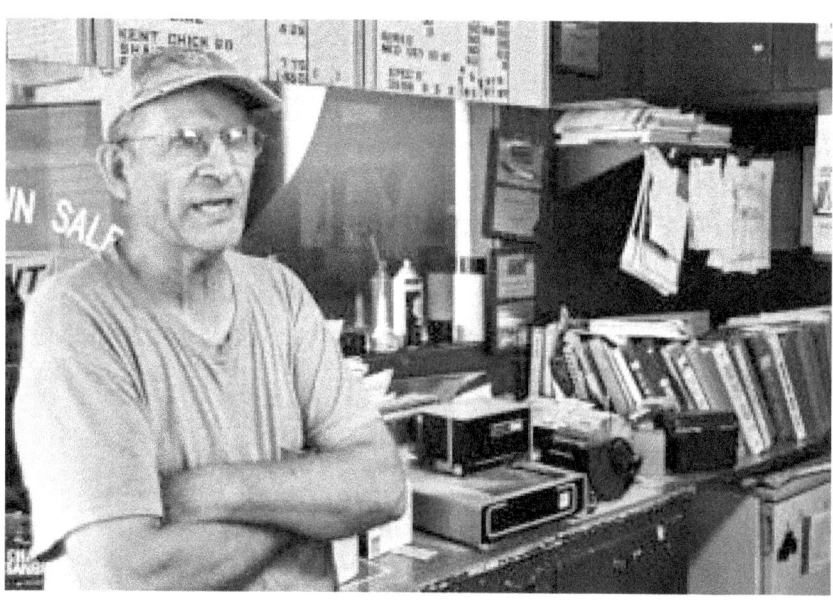

BOB NANDELL

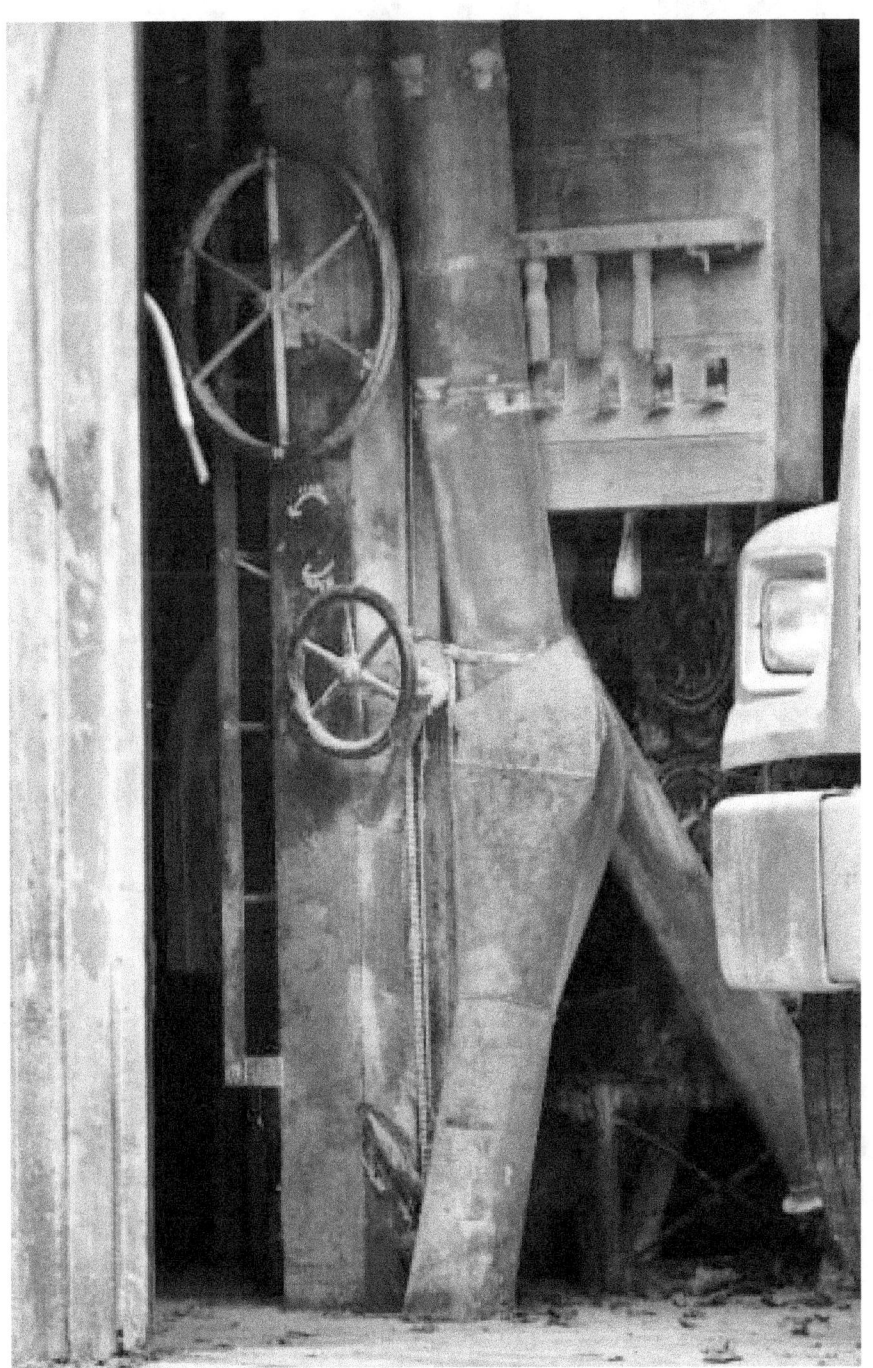

BOB NANDELL

COUNTY LINE ROADS

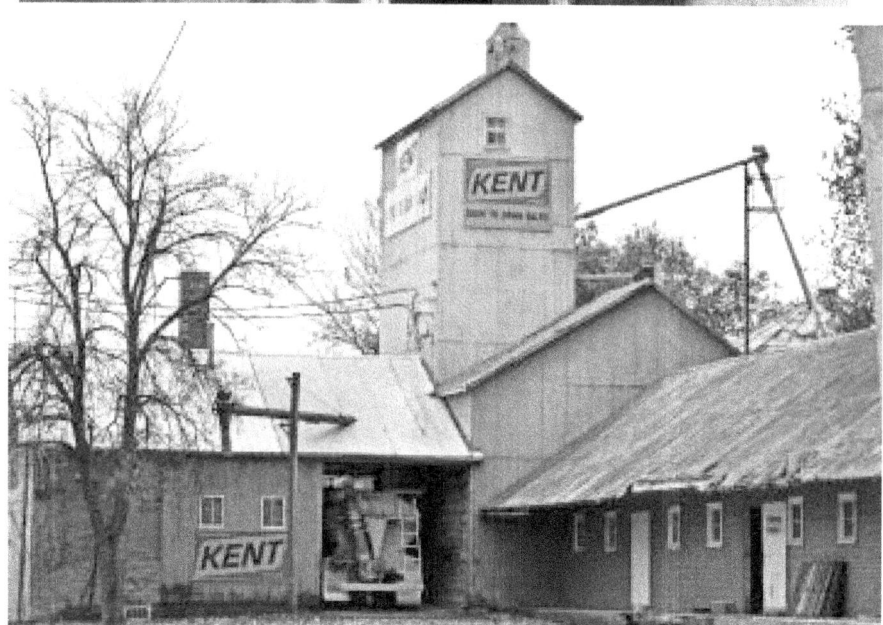

BOB NANDELL

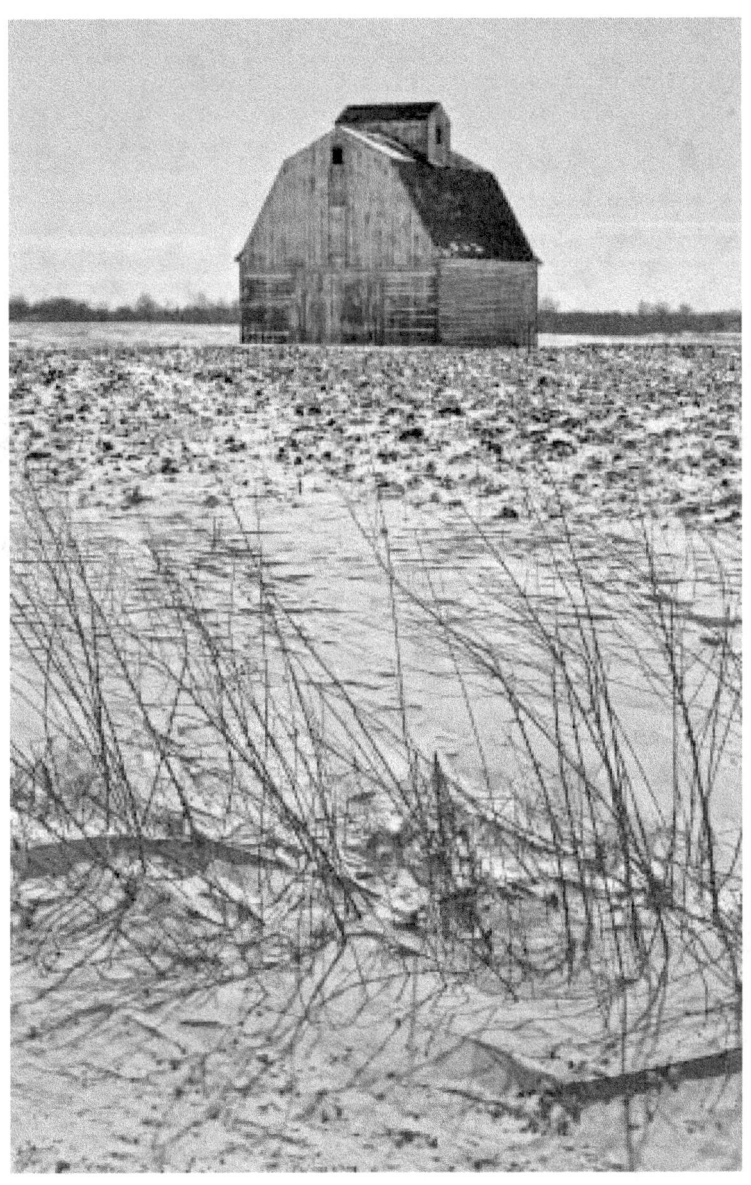

COUNTY LINE ROADS

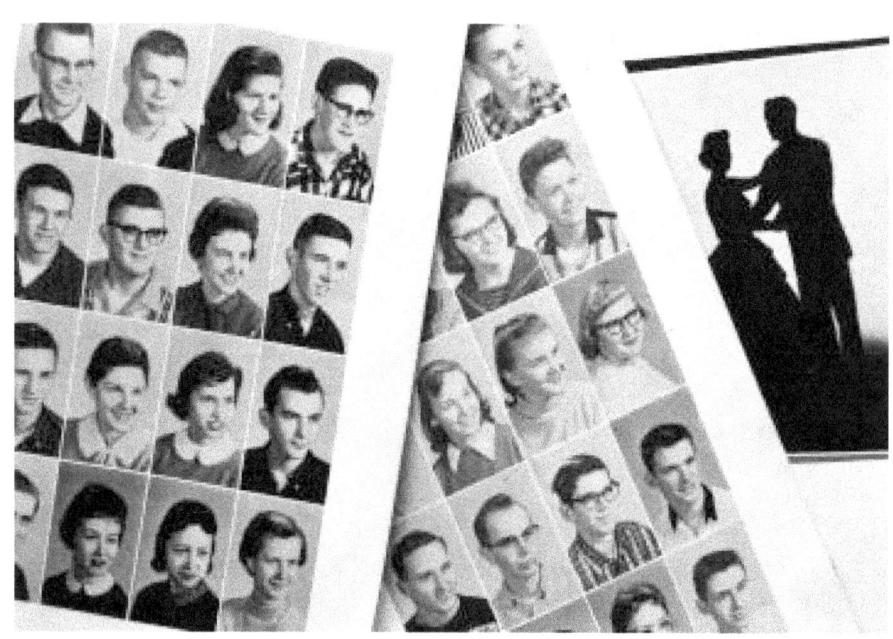

BOB NANDELL

REUNION

Drinks in hand, we gaze astonished.
We gather at Charlie's Grill on County B16.
Yearbook faces have changed.
Time's toll is obvious.
Rounded bellies replace once-athletic figures.
Heads of white replace yesteryear's crew cuts.
Here we are, gathering again.
We stand amazed at what fifty years can do.
Petty teen flings and grievances are forgotten.
Tales are exchanged about hallway pranks
Pulled in buildings that don't even exist anymore.
Our old school's name is now a jumble of letters
Following more rounds of school consolidations.
We remember a kid who was killed in Vietnam.
We remember our best musician, who now plays
In a big city orchestra a thousand miles away.
We remember our class bully, who somehow
Became a lawyer, and then a county court judge.
We agree that the mean teachers who graded us hardest
Were actually the ones who had taught us best.
So here we are, still standing.
We count our numbers and note our losses.
How many will be left next year?
We cherish each other's company.
Will we get to meet one more time?

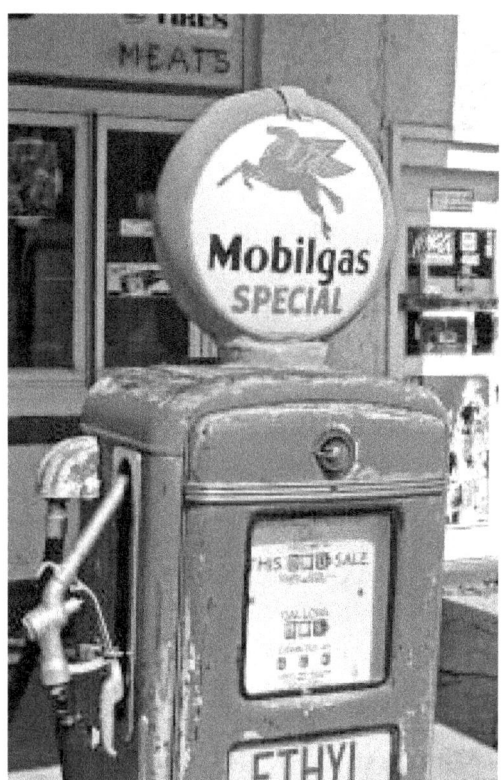

RONNIE'S CORNER

Ronnie had engine oil under his fingernails before he was ten.
He tore his father's lawnmower apart just to see
 what made it go.
His father once came home from Wilson's packing plant to
Find pieces of a Ford flathead V-8 motor neatly laid out.
It was like a great big jigsaw puzzle on his front porch.
Ronnie was rebuilding it to put into his first car.
Ronnie didn't bother to finish high school.
Too many people were having him fix old cars so they could
Keep on driving them, instead of having to buy new ones.
When he couldn't do heavier repairs in his home garage,

BOB NANDELL

He towed them to Dave's corner Phillips 66 station.
Ronnie never pumped a tank of gas for anybody.
He was in back working on carburetors, alternators,
 spark plugs,
Pinion gears, driveshafts, brake shoes, and radiators.
One day state inspectors swooped into town.
They closed Dave's gasoline pumps, claiming they leaked.
But they didn't close down Ronnie's repair bay.
For another twenty years he made a living working out of it.
Ronnie didn't know much about government, money, history,
Mathematics, poetry, music, or politics.
He didn't care.
Ronnie simply knew how to keep old cars running.
People still call his now-empty spot "Ronnie's Corner."

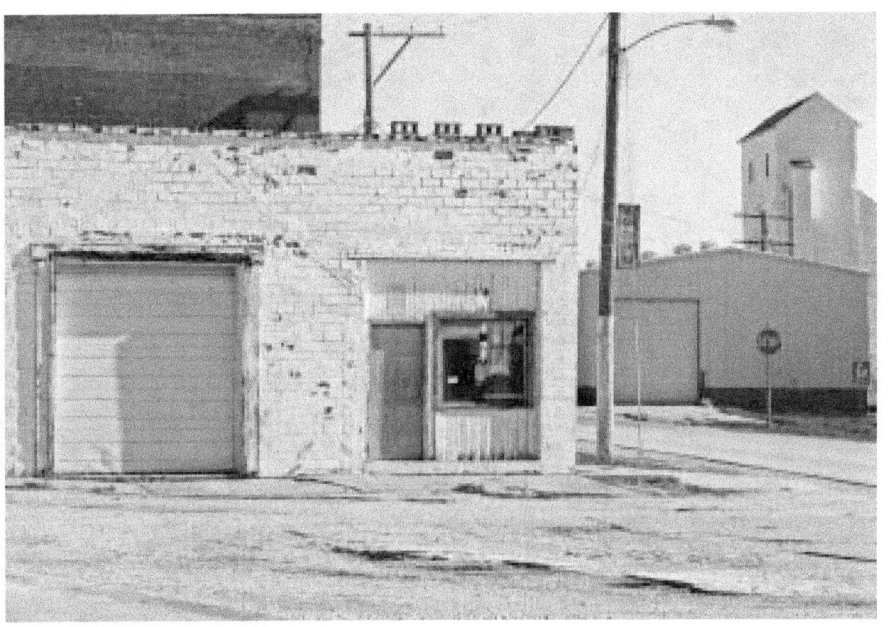

COUNTY LINE ROADS

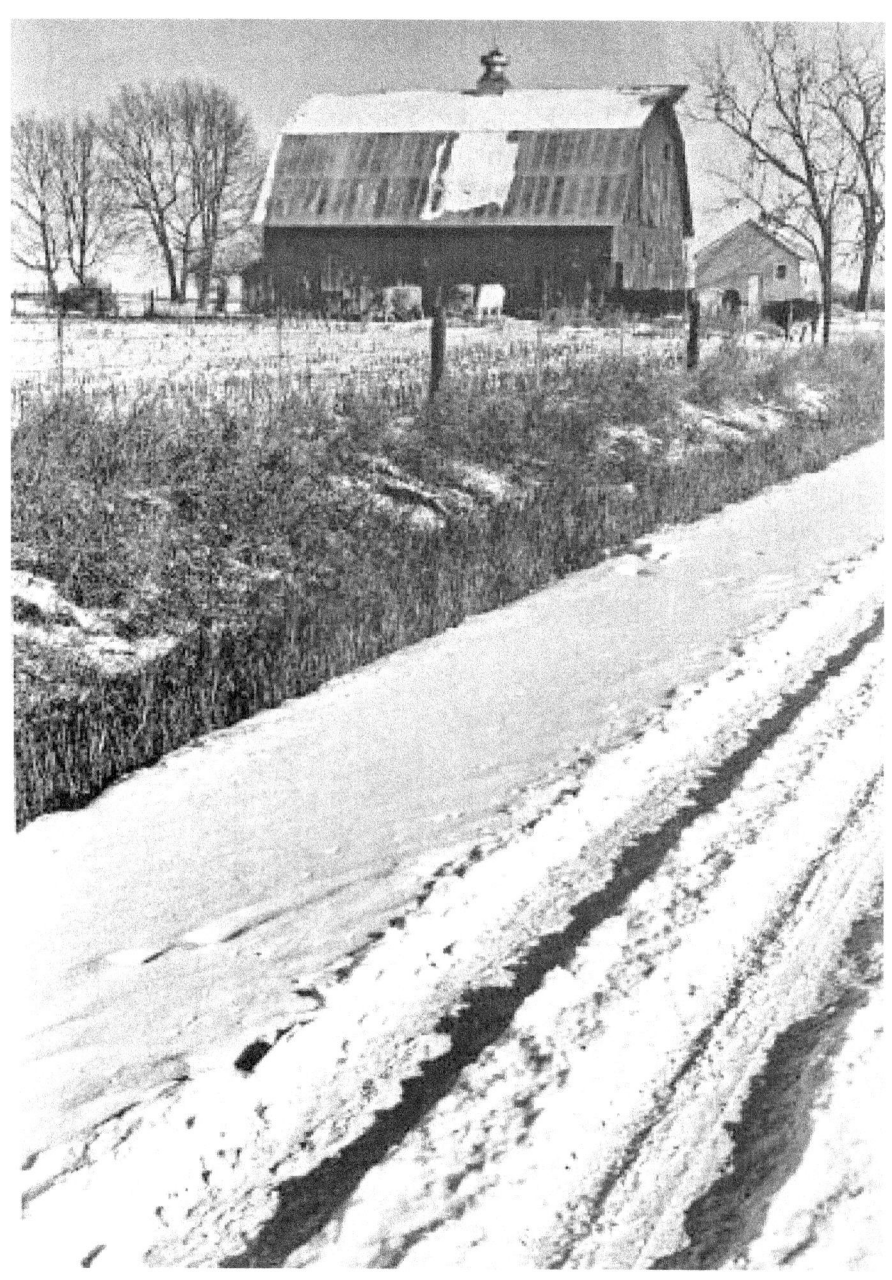

SHEET-METAL ROOF

Eddy's rickety barn on County B17 has a sheet-metal roof.
He liked to listen to winter snow whisper across it.
But he preferred hearing gentle spattering of spring showers.
Summer thunderstorms often added hail with
 great bangs and rattles.
Eddy knew how to determine a storm's severity.
When hail became a great roar he headed into
 a stoutly-built stall.
Eddy's built-in weather gauge served him well.
One evening, roaring hail was accompanied
 by shrieking wind.
A few windows were broken, but Eddy's barn stood firm.
A passing tornado laid a few boards from it
 across his driveway.
A hog confinement building fifty feet away
 was left in splinters.
Eddy can't hear storms anymore, after moving
 to a nursing home.
Eddy's empty old barn out on B17 is slowly falling apart.
Its windows and siding don't stand a chance
 against Iowa winters.
But its sheet metal roof remains intact to this day.

COUNTY LINE ROADS

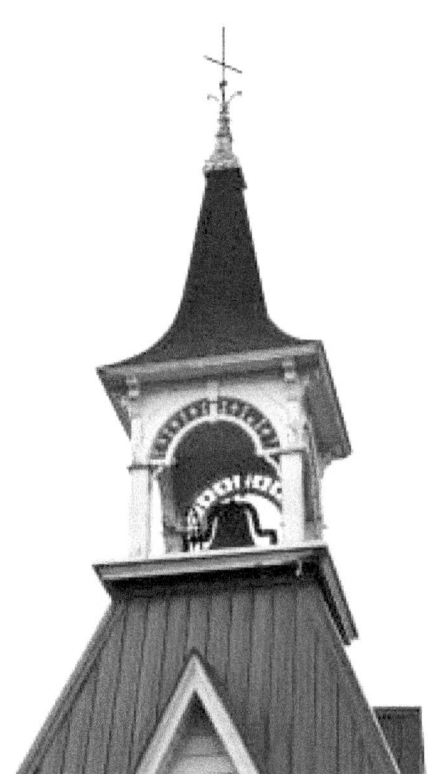

BOB NANDELL

SILENT NIGHT

A little country church Elmer once attended
Sits vacant since most folks moved away,
Weeds grow tall around it.
Its roof leaks.
Elmer attended every Sunday for decades.
But long ago he quit going to Christmas services.
He just couldn't get through them anymore.
When folks sang Silent Night he would melt
Into a flood of tears, remembering his wife.
She had been the soul of their farmstead,
She had tended hogs, chickens, and gardens.
When she didn't wake up one winter morning,
Elmer was too stunned, too hurt, to carry on.
He went to live with his son in town.
His farmstead is now as empty as his church.

COUNTY LINE ROADS

STEEL CASTLES

Curley has seen his horizon on County F10 change fast.
He grew up with wooden corn bins, barns, and houses.
He recognized individual farmsteads by their silhouette.
He could rattle off names of folks who lived on them.
Curley has seen his horizon on County F10 change fast.
Huge grain bins rise like steel castles on distant hilltops.
Where farm houses once stood, metal glistens in sunlight.
Curley can drive miles on County F10 and not see a soul.

Curley has seen his horizon on County F10 change fast.
A tired barn at his place went down after a lightning strike.
It only took a crew four days to replace it with a steel bin.
It looms over Curley's old clapboard farmhouse.
His wife is tired of their drafty, sagging house.
A crew is coming next week to pour a concrete basement.
Then a crew will come and put a factory-built house on it.
Curley's own horizon on County F10 is changing fast.

COUNTY LINE ROADS

BOB NANDELL

STRINGS

Guitar strings meet heart strings.
Notes don't seem to matter to the latter.
Missed flats and sharps bring glances and grins.
Worn, buzzing amplifiers blare on Friday night.
She listens from a darkened gymnasium corner.
Flaming-haired boys turn volume up.
Nothing they are playing is written down.
Feelings don't need to be written down.
Neither does rhythm.
Calloused fingers dance on steel strings.
Stolen kisses float on heart strings.
His microphone is clicked on.
His mind is lost elsewhere.
He sees her and forgets to sing.

COUNTY LINE ROADS

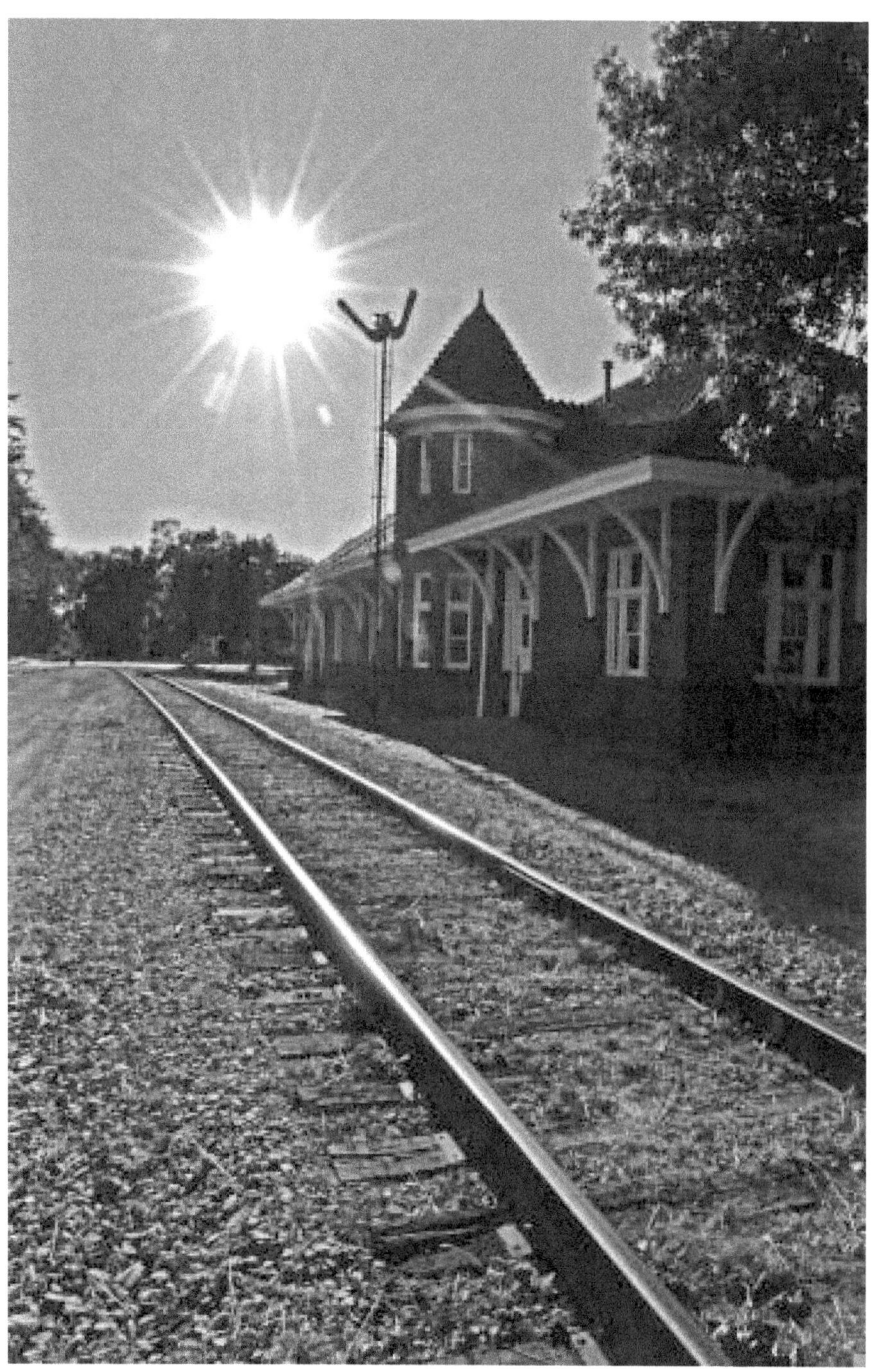

BOB NANDELL

TEACHER

Rupert declared he could teach algebra to a stone.
For several generations of buzz-cut farm kids it was true.
As each semester settled in, he checked endless papers.
He scrawled "This is good" on ones done well.
He scrawled "Try again" on ones that weren't.
A's, B's, C's and a few D's would come later.
All his pupils stood a good chance of surviving his class.
Rupert believed in giving everyone a chance.
His chance came through the GI bill after the war.
He wanted to be a teacher in a clean, warm classroom.
It beat shoveling corn to cattle on below zero mornings.
No way was Rupert going back to his father's farmstead.
Rupert liked mathematics because it was structured,
Just like the years of structured Army life he had endured.
Rupert declared he could teach algebra to a stone.
For several generations of buzz-cut farm kids it was true.

COUNTY LINE ROADS

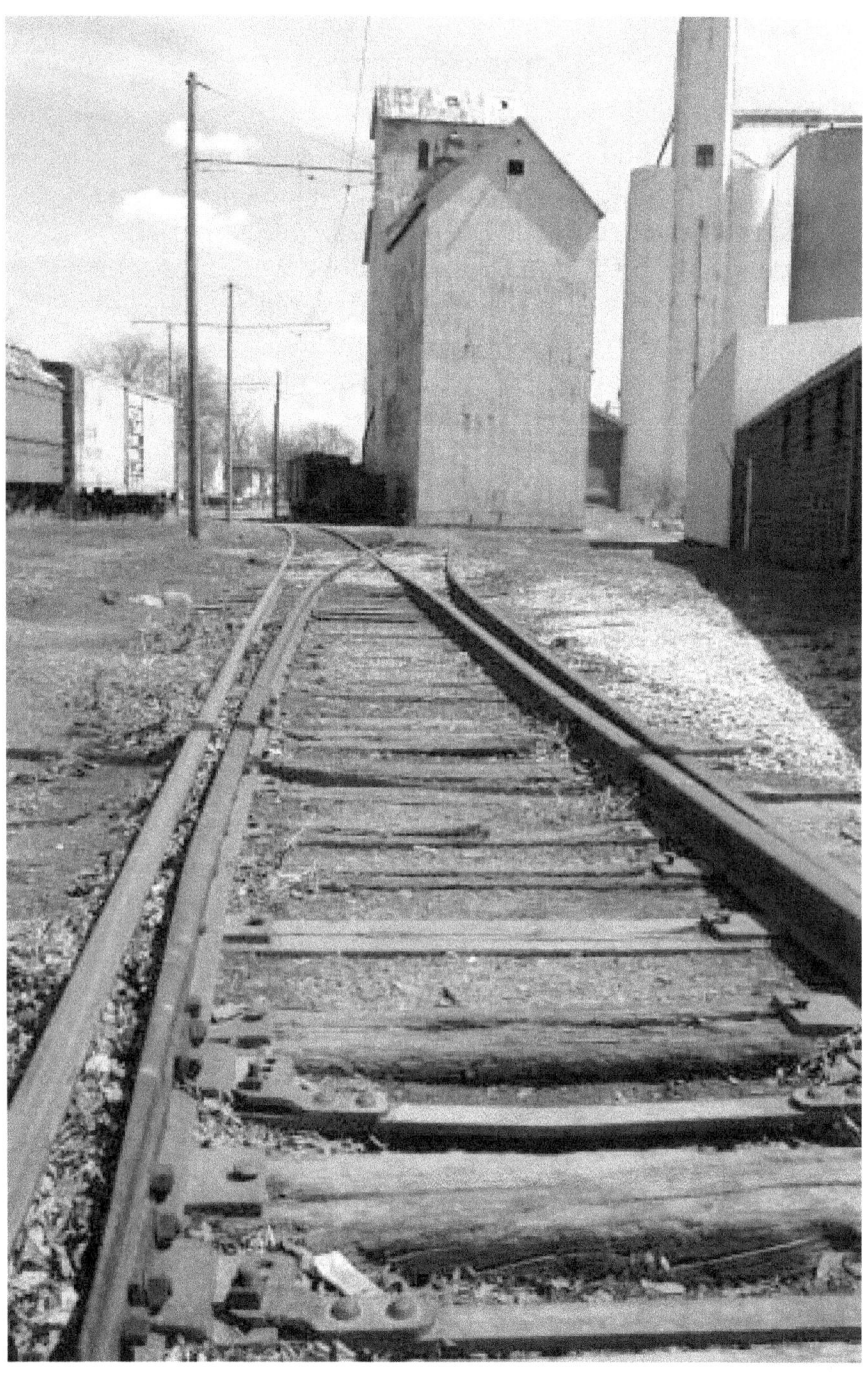

BOB NANDELL
TRACKS AND TRUCKS

Harley can tell by springs in rail car wheel trucks
Which ones are fully loaded with soybeans.
One-hundred-ton hopper cars are easy to move
With an end-loader and chain, if you're careful.
Iowa Northern locomotives come through weekly.
They add five or ten more cars to their train.
Hoppers full of grain leave to feed distant lands.
Big main lines are filled with container trains and
Refrigerated trains, rolling from coast to coast.
They have little time to bother hauling grain cars.
Harley wonders how much more time is left
For this spur line to haul its tonnage southward.
How long before this track will disappear too.
How long before this roadbed becomes another
Bicycle trail between two little towns.
How long before endless streams of semi-trucks
Have to shoulder loads as consolidation continues.
How dumb, he thinks, can a country be to allow
Its rail traffic to end up on blacktop county roads?

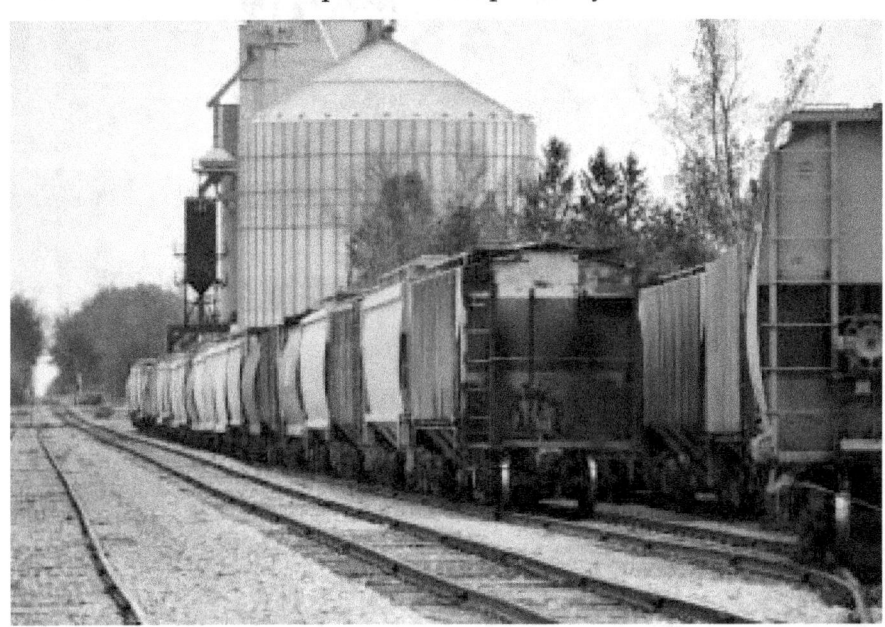

TWO HUNDRED ACRES

Ralph doesn't care to see other world places anymore.
Ralph doesn't really care to be around other people either.
Ralph lives on two hundred acres his old man willed to him.
He has two hundred hogs in confinement buildings to care for.
Ralph remembers slogging through swamps
 in North Carolina,
Part of Marine Corps basic at a place called Parris Island.
He still walks with a limp because of mortar shrapnel
 in his thigh.
He got that in a place called Kuwait during
 Desert Storm in 1991.
Ralph remembers drinking great beer while
 mending in Germany.

BOB NANDELL

That was before his flight home to be processed out
 of active duty.
Ralph doesn't care to see other world places anymore.
Ralph really doesn't care to be around other people either.
Ralph is content to live on his acres of black north Iowa earth.
His beat-up four-wheel-drive is coated with wind-blown dust.
Ralph occasionally splits chilly autumn air
 with his pride and joy,
A Winchester rifle he bought with some
 of his disability money.
He laughs about "pea-shooter" rifles he was
 sent into war with.
He hits pie plates nailed on fence posts
 two hundred meters away.
Ralph is quite content to live alone out on County Road B20.
He's proud to say he doesn't owe anybody a dime either.

COUNTY LINE ROADS

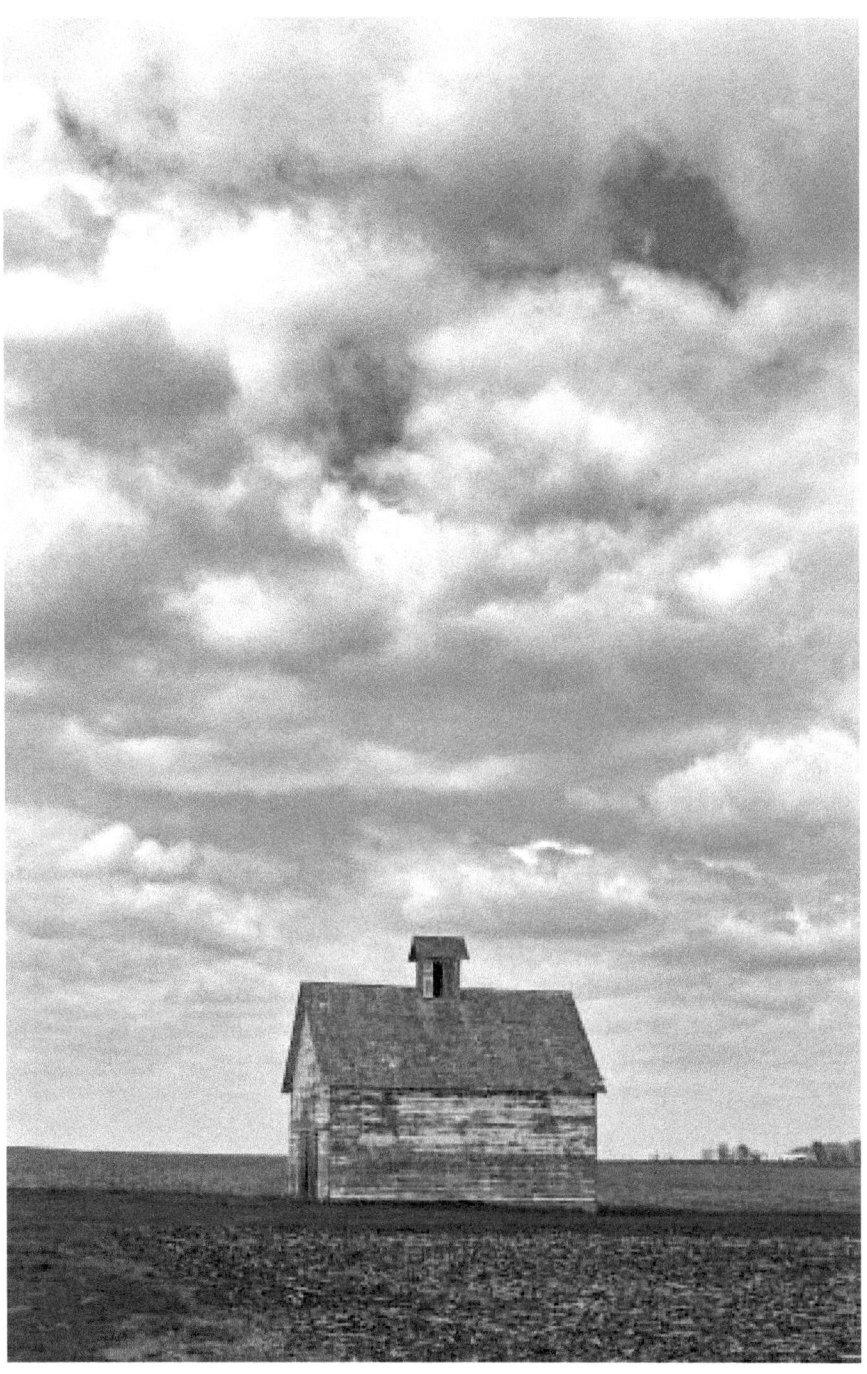

BOB NANDELL

VISTAS

Where some saw only arcs of sky
 against endless prairie grasses,
Others imagined barns and farmhouses.
Where some saw only junctions of small streams,
Others imagined towns and buildings.
Where some saw only rock formations,
Others imagined quarries and blocks of limestone.
Where some saw only empty valleys stretching below them,
Others imagined routes for railroad lines.
Around them was ground that could produce
 crops and livestock.
They did not delay.
They knew lifespan limitations.
But they also knew resources given them were limitless.
They did not delay.
Theirs was a generation of doers.
Theirs was a generation of builders.
Theirs was a generation of winners.

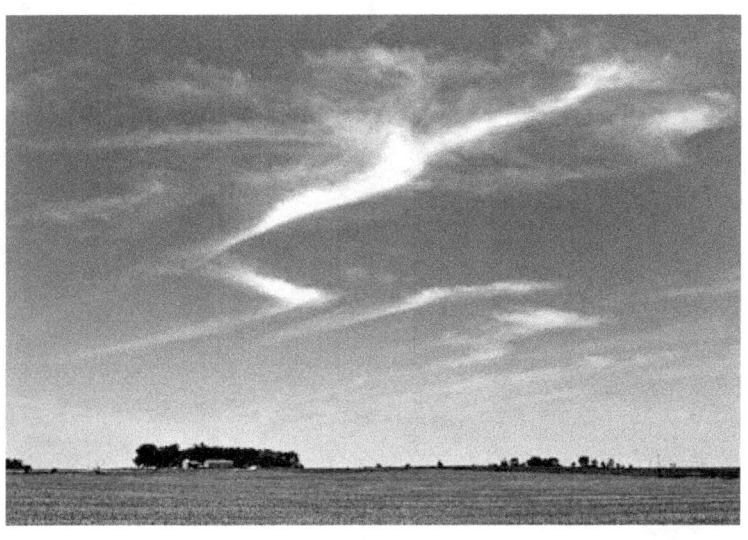

COUNTY LINE ROADS

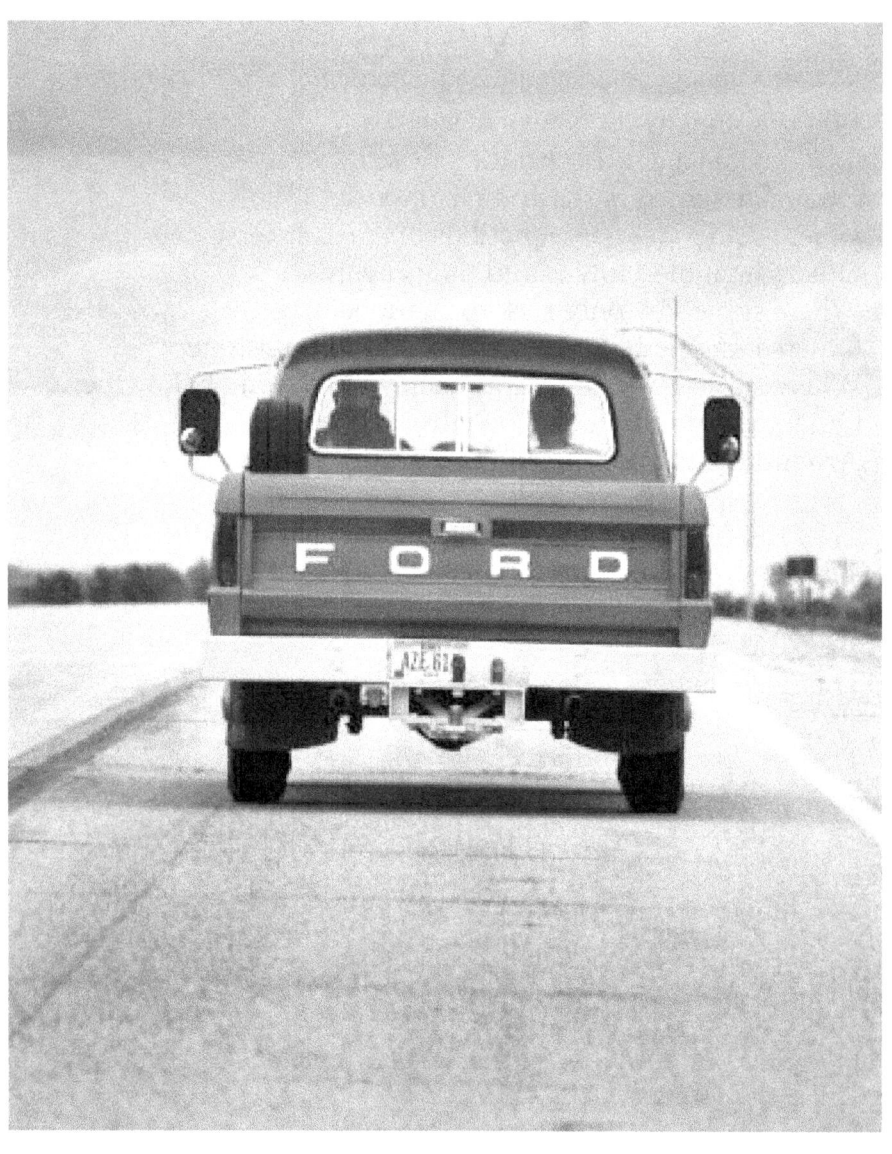

BOB NANDELL

WEED COMMISSIONER

Lenny's retirement job was perfect.
His cousin appointed him county weed commissioner.
It really didn't pay much, but it gave Lenny something to do.
All summer Lenny would drive around in a county pickup.
Down endless miles of county roads he hunted his prey.
Lenny sprayed ragweed, cocklebur, and lamb's quarters.
Some summers he would pay a high school kid
 to ride with him.
The kid chopped weeds while Lenny sat in his truck reading.
Most often he spent time chatting at farmsteads
 with folks he knew.
Lenny knew crop conditions better than
 farm service officials did.
Lenny also knew where some luxurious patches
 of marijuana were.
He even figured out who had planted them
 at select cornfield edges.
Sheriff Jim busted out laughing when Lenny pulled in
 one afternoon.
Lenny's truck bed had two hundred pounds
 of freshly-cut weed in it.
It made a great front page photograph for Ed
 at *The Weekly Record*.
It made a glorious bonfire later behind county
 maintenance sheds.
What Sheriff Jim didn't know about was those other
 choice patches.
Lenny had sense enough to avoid trouble by leaving them be.
He figured there were some things nobody
 needed to know about.
He was weed commissioner for almost a decade.

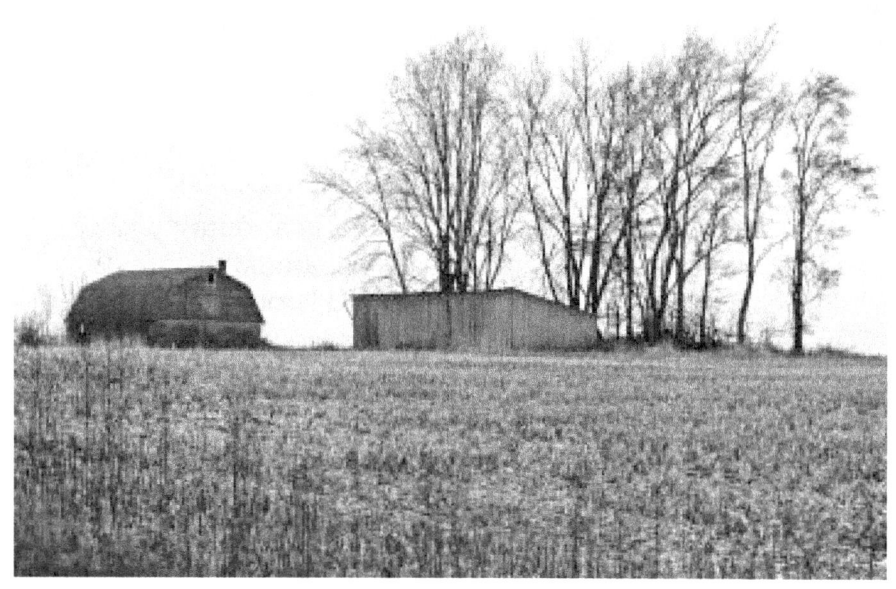

WINDBREAK

It was wind.
Wind constantly moaning, roaring, shrieking,
 whispering, clawing, howling.
A carefully planted windbreak of trees protected
 Dexter's small farmstead.
Only a few others like it broke wide, empty expanses
 along County R14.
It was wind and too many glasses of cheap vodka
 that made him leave.
Wind and too many failures in his life made him crazy.
It was wind.
Wind that blew dust and cornstalks against
 his weathered siding.
Wind that tore rows of shingles off his roof.
Wind that shut him in for days with snowdrifts
 across his driveway.

BOB NANDELL

Wind that slowly demolished his outbuildings
 except for his barn.
Wind that pitted the sides of his pickup truck
 with small rock marks.
Wind that left his face with more lines than
 a county road map.
Dexter hates his senior citizens' center apartment.
He detests his neighbor's televisions
 blaring idiotic game shows.
When he can't stand it anymore, he drives back out
 to his old place,
Sits in his truck and listens to wind rattling tree limbs.
He thinks of constants in his life – farming and his late wife.
He also thinks of what finally drove him into town.
It was wind.

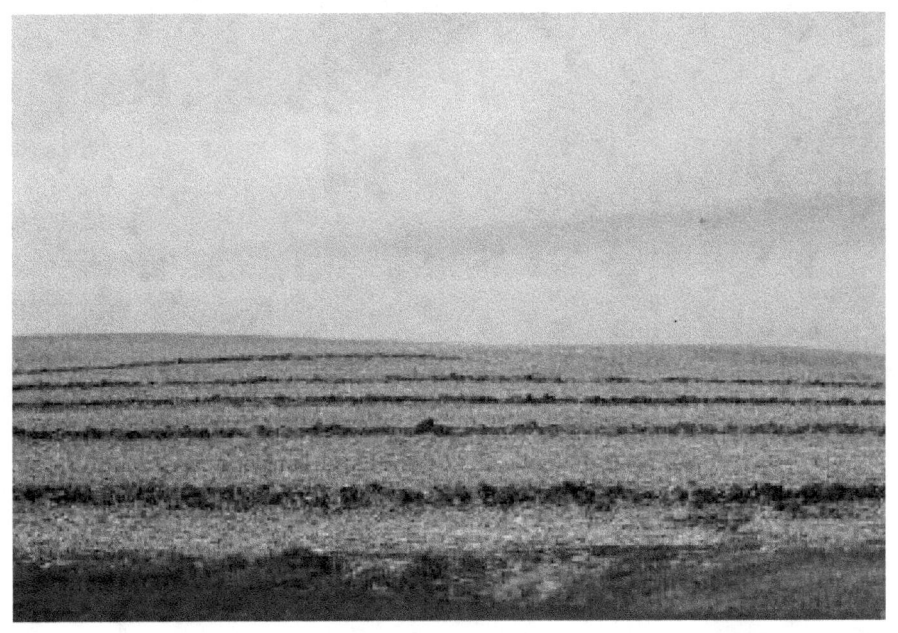

COUNTY LINE ROADS

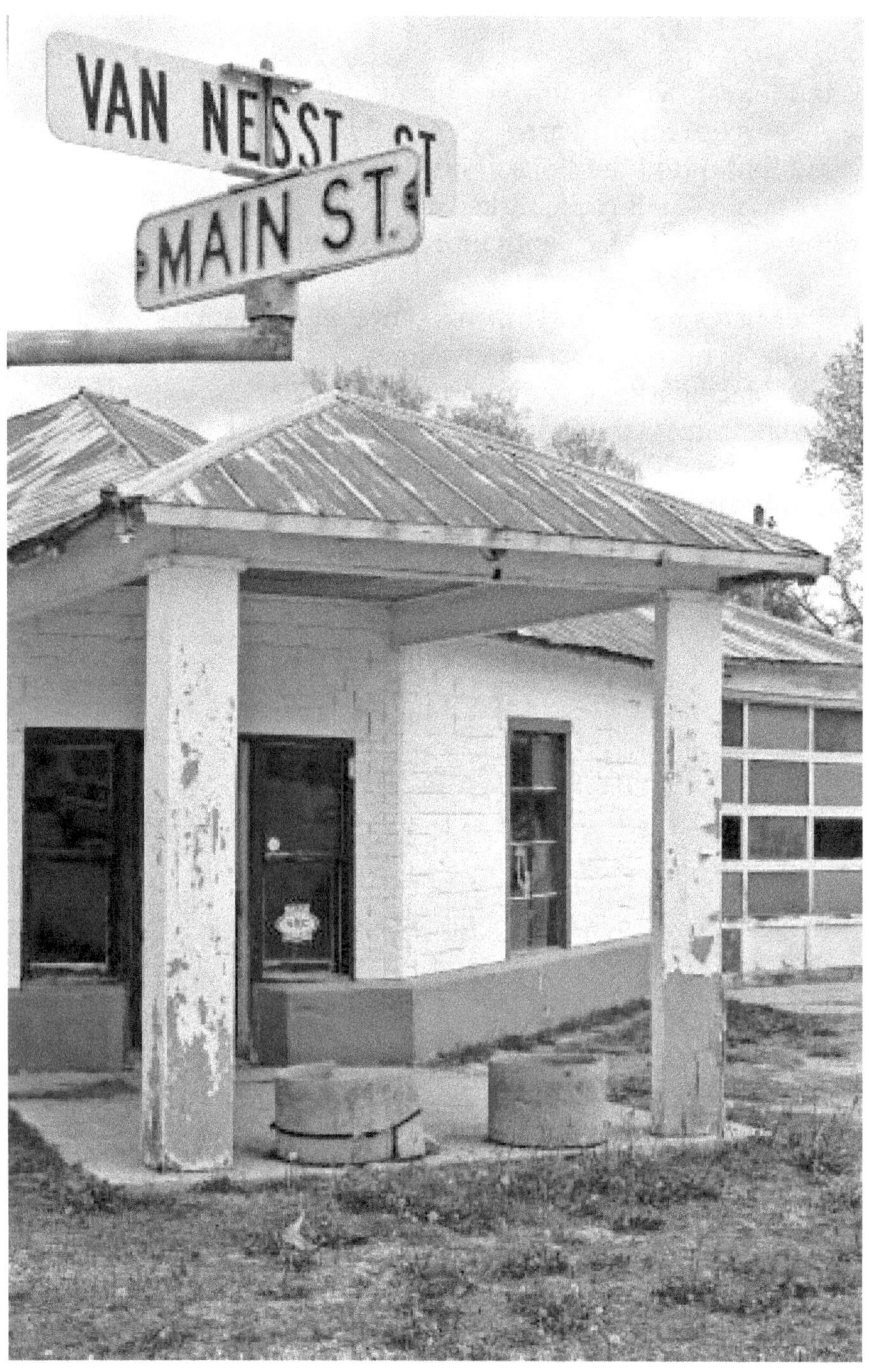

BOB NANDELL

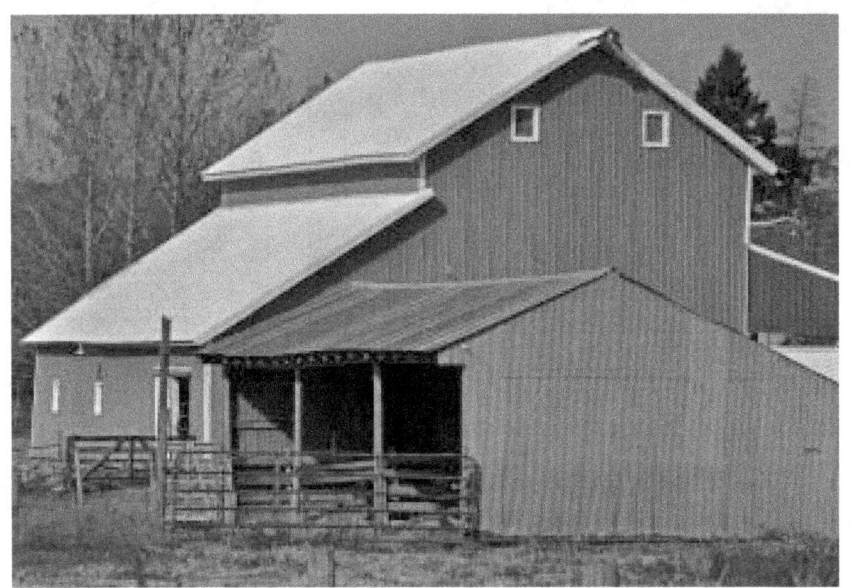

ABOUT THE AUTHOR

Bob Nandell is a retired *Des Moines Register* photographer. He is the author of several photography and poetry books dealing with the changes in Iowa's rural and small-town landscape, including *A Certain Longing* (1995), *Empty Windows* (2008; new edition 2013) and *Maple Street Stories* (2012). He is also the author of an illustrated book of religious reflections, *Offerings & Sacrifices*.

Nandell, a native of Iowa City, is a 1964 graduate of the University of Iowa journalism school. He has worked for newspapers in Davenport, Iowa; Milwaukee, Wisconsin; Mason City, Iowa, and Des Moines, Iowa during his 43-year newspaper career. He lives in West Des Moines, Iowa.

For more information about these and other books, calendars and products, visit **www.pbllimited.com**
PBL Limited
P.O. Box 935
Ottumwa Iowa 52501

www.ingramcontent.com/pod-product-compliance
Lightning Source LLC
Chambersburg PA
CBHW072039190526
45165CB00018B/1181